Secrets of Successful
AERIAL
Photography

RICHARD ELLER

AMHERST MEDIA, INC. ■ BUFFALO, NY

Published by:
Amherst Media, Inc.
P.O. Box 586
Buffalo, N.Y. 14226
Fax: 716-874-4508
www.AmherstMediaInc.com

Publisher: Craig Alesse
Senior Editor/Project Manager: Michelle Perkins
Assistant Editor: Matthew A. Kreib

ISBN: 1–58428–018–2
Library of Congress Card Catalog Number: 99–76590

Printed in the United States of America.
10 9 8 7 6 5 4 3 2 1

TABLE OF CONTENTS

Chapter 5

FILM CHOICE .42

Chapter 6

EXPOSURE .46

Chapter 7

PREFLIGHT PLANNING51

Chapter 8

SELECTING THE AIRCRAFT59

INTRODUCTION

Aerial photography is almost as old as photography itself. The first use of a camera to record the view from above occurred in 1858 when Nadar, aloft in a balloon, took a photograph of a French chateau below him. Realizing the value and uniqueness of the view, he produced a series of photographs of Paris, which he sold to the public. These were an instant success, and the business of aerial photography was born. Over the years, a number of various methods have been employed to capture the eagle's view. Many have proven successful and are still in use today, while other

"Aerial photography is almost as old as photography itself."

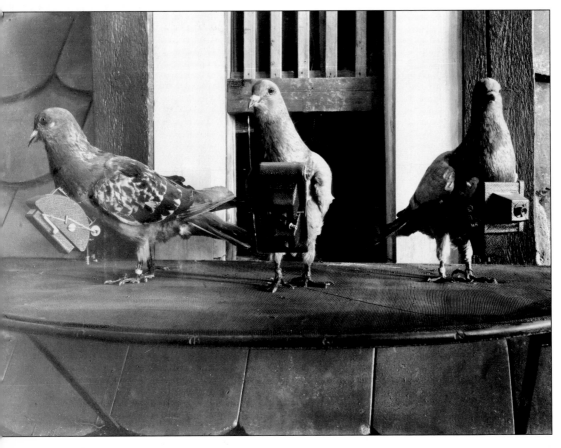

In the early 1900's, pigeons were outfitted with small timer-controlled cameras.

The Itaglio Man, a prehistoric figure, was unknown even to local indigenous groups until photographed by the United States Air Force in 1932.

methods, such as outfitting homing pigeons with miniature cameras, seem almost silly. Although, I suppose the results of the latter could be called a true "bird's eye view."

Until recently, the majority of aerial photographs were taken for the information they could provide. Engineering, construction, mapping, and surveying all rely heavily upon the camera's ability to provide an impartial representation of the earth. This is known as photogrammetry and, with the addition of rocket and satellite imagery, has become the science of remote sensing. Requiring highly specialized equipment and training, this type of aerial photography is beyond the scope of this book. However, the invention of small, lightweight cameras and lenses has opened the door for many other styles of aerial photography. Just as the 35mm camera freed the photographer of cumbersome field cameras and film packs, today's fast shutter speeds and improved films have allowed him to easily take to the sky. In this book, I will describe

the making of aerial photographs using equipment and procedures readily available to everyone.

In fact, aerial photography is little different from ordinary ground photography. The procedures are more complicated and do require thorough planning, preparation, and attention to detail. However, anyone who can operate a camera can take aerial photographs. The techniques and procedures are straightforward and easily mastered. In truth, there is only one essential requirement: you must love to fly.

Inside information on the unique characteristics of aerial photography, and the conditions aerial photographers encounter, will provide solutions to specific problems. Drawing upon twenty-five years of professional experience, I will supply the valuable tips and techniques needed to insure your success. Included are discussions of atmospheric conditions and scene characteristics, camera and film selection, and basic exposures. Preflight planning, aircraft suitability, and pilot communications will also be examined. A section on markets for aerial photographs, with information on how and where to sell your images, completes the package. Explained in detail is everything you need to become a successful aerial photographer. It is assumed that the reader knows how to use a camera effectively, and that no instruction in basic camera skills is required. The purpose of this book is not to teach you how to become a good photographer, but to teach you how to become a good AERIAL photographer.

Whether you are a professional photographer searching for ways to expand your market, an amateur seeking a new viewpoint, or a pilot looking to snap a few shots of your travels, you will find the information you need in this book. In a very short time, you will return with quality photographs of your time aloft. Aerial photography can be a rewarding and enriching experience. I know it is something I always enjoy.

Good luck and safe flying!

Opposite top, U.S. Fleet entering San Francisco Bay, October 1942. Opposite bottom, San Francisco Bay today

"Aerial photography can be a rewarding and enriching experience."

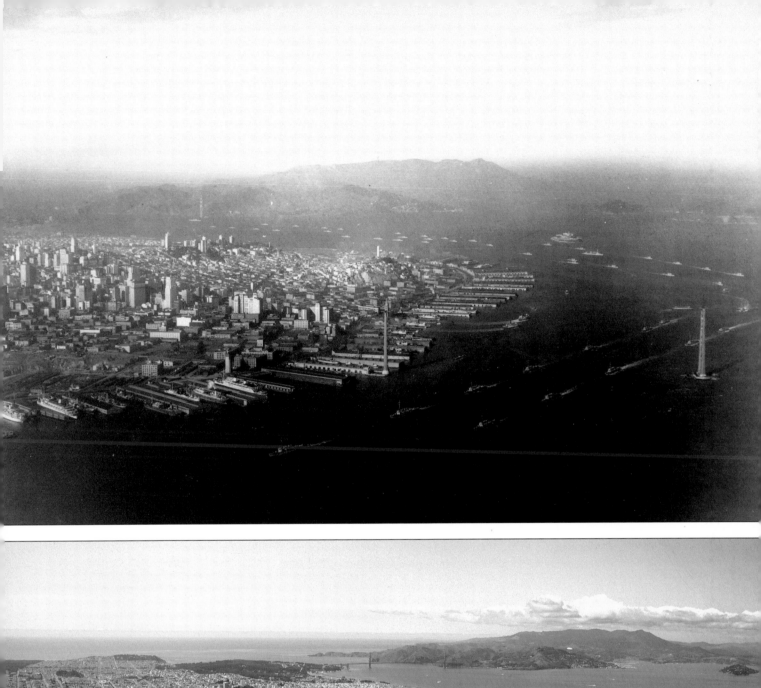

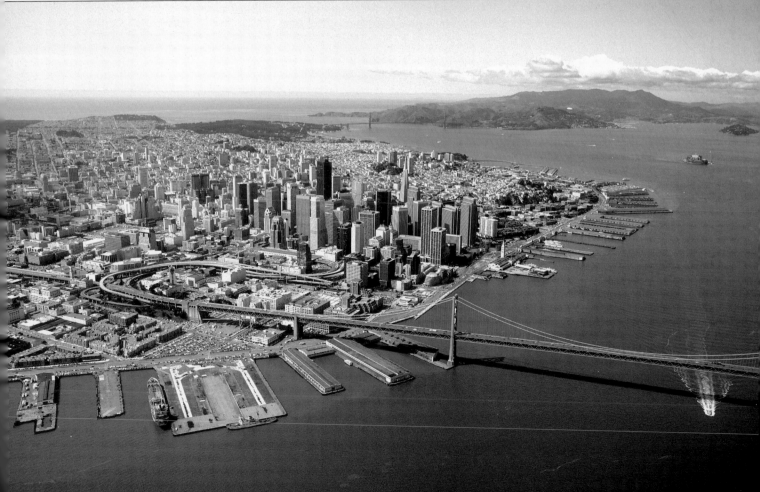

OVERVIEW 1

With the Earth as a subject and the sun providing the light, aerial photography is photography in its purest form, providing information and beauty and allowing mankind to travel to places unknown. From the bird's eye view of a small village square to the view of the Earth from outer space, aerial photographs have opened our eyes to new perspectives and increased our awareness of the world around us.

"Aerial photographs have opened our eyes to new perspectives."

◼ Sun as Sole Light Source

As in all outdoor photography, the aerial photographer is dependent upon the sun to illuminate the subject. As the sole light source, it dictates the best time of day, and often the best time of year, for a given subject location. Fortunately, it is predictable, staying the same distance away and producing the same amount of light each day. Over the years, solar charts have been compiled which show the position of the sun for a given location at any time of the day throughout the year. These make it possible to predict the subject illumination from sunlight far in advance. However, in aerial photography it is not only the distance from the camera to the sun that must be taken into consideration but the distance from the camera to the subject as well.

The scattering of light particles by the atmosphere it passes through has been well documented by science. It is this scattered light that makes the sky appear blue and the rays of the setting sun red. We often take for granted the effects the atmosphere produces on what we see. When we perceive objects on the horizon, we attribute the lightness and lower contrast to our physical distance from the object, not to the increased scattering of light by the intervening atmosphere. This visual effect has long been valued by pictorial photographers and painters for its ability to add scale and depth to a two-dimensional representation.

Right: The image of the Earth from outer space has had a profound effect on mankind and his relationship with the planet.

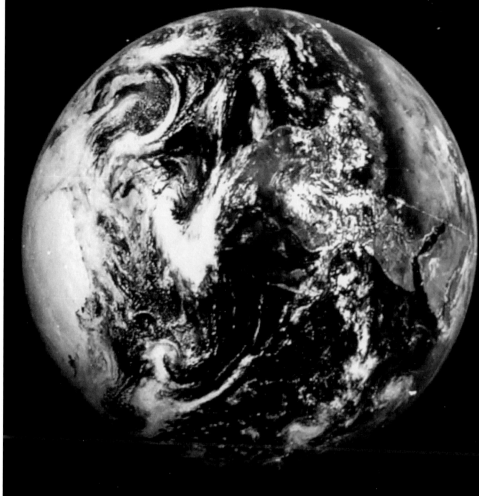

Below: When combining multiple buildings in one shot, try to find the angle where none of the buildings overlap in order for all of them to maintain their individual appearances.

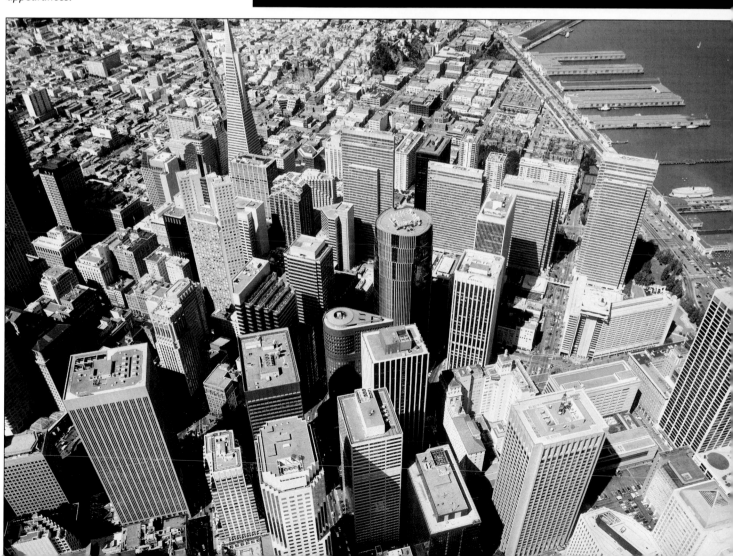

Even when photographed from relatively low altitudes, the sunlight reflecting from a subject must travel through thousands of feet of atmosphere before reaching the camera position. The effects produced by the additional air the light must transverse and the techniques for dealing with them are what sets aerial photography in a class by itself.

An aerial view can show the relationship of the buildings and the landscaping better than a ground level view.

☐ Effects of Motion

Aerial photographers must also deal with the effects produced by motion. Not only the motion of the subject, such as a car or a train, but motion of the camera as well. The ability to track objects in 3-D is essential. Along with the normal aspects of backwards/forwards and left/right, aerial photography includes the up/down dimension of altitude. The photographer must watch as the subject and its relationship to other objects change, anticipating when everything – the subject, the foreground, and the background – aligns in perfect composition to create the desired image. Motion forces the aerial photographer to use judgement and experience to predict and then capture the proper moment for exposure.

"The ability to track objects in 3-D is essential."

☐ Styles of Aerial Photography

As a separate discipline, aerial photography has also developed unique styles and image formats that differ from ground-based photography. There are three basic compositions that are used for aerial photographs.

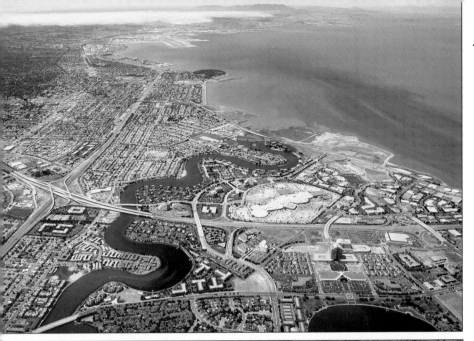

☐ **High Oblique. (top)** Taken from an angle of approximately 70 degrees off the vertical axis, the high oblique does include the horizon and the sky. This is the view most people associate with looking out of an airplane window. It is recommended that one shoot at least 10 degrees off the horizontal axis to avoid including an excess of sky in the photograph.

☐ **Low Oblique. (center)** Taken from an angle of approximately 40 degrees off the vertical axis, a low oblique does not include the visible horizon or the sky in the picture frame. The horizon line is implied through receding lines and the difference in size between foreground and background objects.

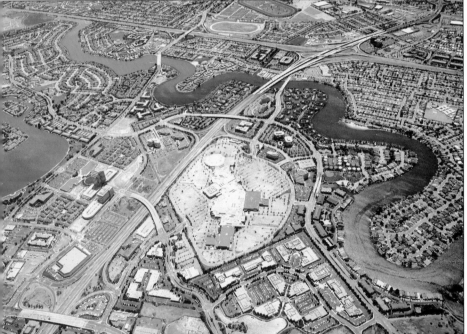

☐ **Vertical. (bottom)** A vertical format is taken with the camera pointed straight down and with all four corners equidistant from the film plane, producing a map-like perspective. Although in some ways the most abstract view, a vertical format has the advantage of providing a readable scale to the photograph.

The scale is calculated as the ratio of the focal length of the lens to the altitude of the aircraft. Thus, a 50mm (2 inch) lens on a camera photographing from an altitude of 2,000 feet (24,000 inches) would be expressed as a scale of 2/24,000, or 1/12,000. This means that 1 inch on the photograph equals 12,000 inches (or 1,000 feet) on the ground.

☐ Best Times of Day to Shoot

The best time of day is another difference between aerial photography and other types outdoor photography. As a whole, most outdoor photography occurs before 10:00 AM or after 2:00 PM to capture the qualities of early morning and late afternoon light. However, in many situations, the rule for aerial photography is just the opposite. On the ground, the long shadows cast by the low level of the sun are usually hidden behind the subject. But in the air, where you can see over and around objects, the shadows can be intrusive and lessen the readability of the photograph. This is particularly true when photographing large cities or urban areas where buildings can cast deep shadows and thereby obscure detail in the streets.

> "...most outdoor photography occurs before 10:00 AM or after 2:00 PM..."

Late afternoon sunlight can create heavy shadows that obscure subject detail. Therefore, many subjects are best photographed at 12 noon to minimize shadows.

☐ Composing Aerial Images

Aerial photographers also face one other unique challenge when composing an image: the problem of showing too much. As the altitude increases, the amount of the ground below that is included in the photograph also increases. At high altitudes, details on the ground become smaller and harder to recognize, providing fewer visual clues for the viewer. In addition, there is a decrease in the overall scene brightness and contrast due to the increase in atmosphere between the subject and the film.

In many ways, aerial photography is both more and less complex than other forms of photography. However, the skills and tech-

niques needed to obtain repeatable results are easily learned through careful observation and good judgment. As a form of outdoor photography, success rests largely upon the environment. Therefore, a basic understanding of the atmosphere and its effects upon photography is essential for successful aerial images.

Which shot conveys a better view of the subject? A higher altitude (bottom) allows for a wider view, but a tighter focus (top) makes the subject more recognizable. The intended usage of the image determines which shot is more appropriate.

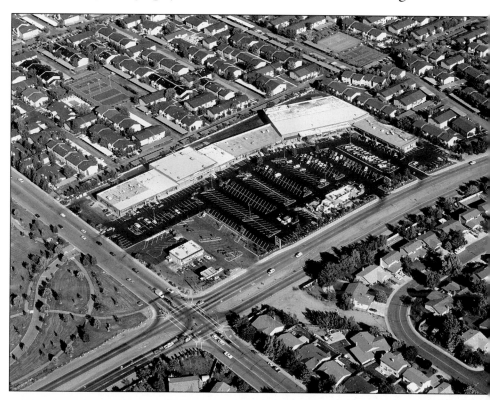

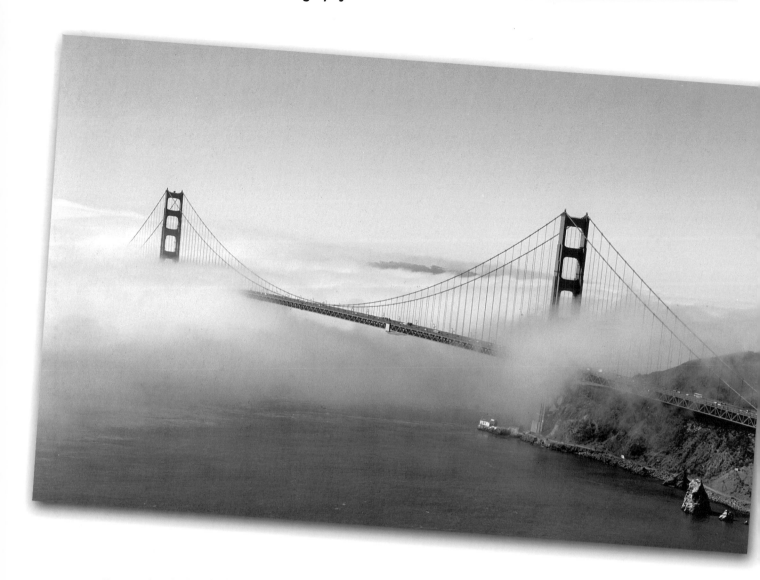

Usually occurring during the late summer, the famous San Francisco fog is a somewhat predictable weather condition.

ATMOSPHERIC CONDITIONS AND SCENE CHARACTERISTICS 2

"... nature plays a vital role in determining the outcome of an aerial shoot."

As in all outdoor photography, nature plays a vital role in determining the outcome of an aerial shoot. The time of day, angle of sun, and weather all have a direct impact upon the image. They help create the mood, the feel of a picture, and dictate the parameters needed to achieve a desired result. Aside from issues of safety and of prudent flying, weather conditions alone can determine if a flight will be productive. In aerial photography, atmospheric conditions and scene characteristics are the two most important factors to consider when making film and equipment choices. Ultimately, they can determine the outcome of your endeavors.

■ Nature's Effect on Aerial Photography

When shooting from a plane, the sun is your only light source. You can't add a fill light or use a reflector to open up shadow detail. Nor can you move the subject to the left or the right for better lighting. Therefore, selecting the right time of day, and often the right time of the year, is critical. Equally important is subject matter. Buildings, forests, and large bodies of water all present unique problems to the aerial photographer. In later chapters we'll take a more detailed look at specific film and equipment choices to meet these challenges. First, let's examine the overall effects nature can have on an image.

• Time of Day / Time of Year

Although the distance to the sun remains a constant 94 million miles, the axis tilt of the earth causes our relative position to change. From winter solstice to summer solstice, the sun rises higher relative to our horizon as the days grow longer. The angle of the sun determines the best time of day, as well as the best time of year, for all outdoor photography. For general purposes, most aerial photography takes place between the hours of 10:00 am to

Opposite. Although long shadows can make a dramatic image, most aerial subjects photograph better during mid-day.

Below. Beware of the shadow cast on the ground by your aircraft and try not to include it in your photograph.

4:00 p.m. Early morning or late afternoon shadows can make for a dramatic image, but deep shadows will obscure much of the scene below. From October to March, the long shadows of winter make the "ten to four" rule especially important.

Equally important is your camera position relative to the sun. Having the sun at your back or slightly to the side is preferred. Always be aware of the shadow cast by your plane on the ground below and try not to include it in your photographs. Generally speaking, it is best to shoot to the west in the morning hours and to the east in the afternoon. Camera position will also determine how blue the sky will appear in the photograph. Although a northern view will always produce the deepest color, keeping the sun behind you will help keep the sky from washing out. Always remember that during Daylight Savings, the sun will be at it highest point in the sky at one o'clock, not noon.

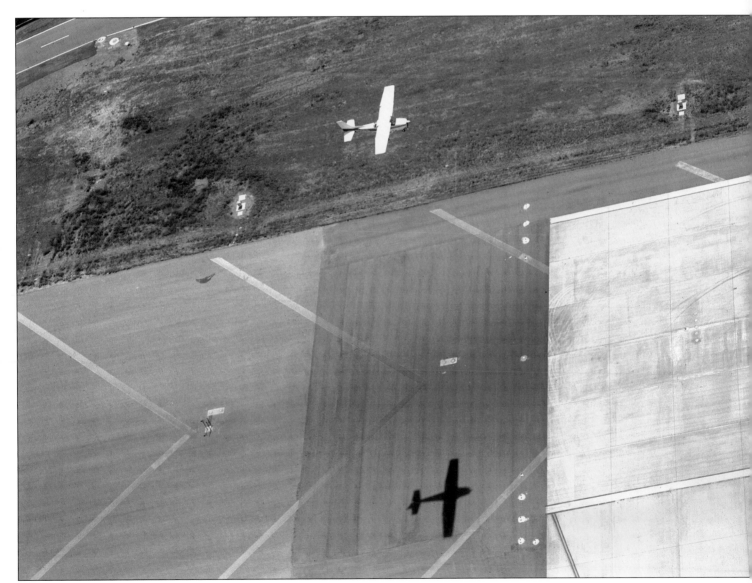

Certain subjects benefit from an overcast sky. When photographed from this angle, the buildings pictured face north and never receive direct sunlight (top photograph). Photographing under an overcast sky (bottom photograph) helps to reduce the overall contrast and remove harsh shadows.

• Clouds

Because cloud formations come in a wide variety, their effect upon aerial photography is difficult to predict. High, thin, cirrus clouds may decrease the light level very little, but they will diffuse the illumination. The result will be flat lighting and decreased scene contrast. At times, this can be a benefit by reducing highlights and scattering light into the shadows. Large, fluffy, cumu-

"... use film with a wide exposure latitude."

lus clouds will cast dark shadows and obscure any detail beneath them. As a general rule, at least 70% of the sky must be clear for successful aerial photography. Because of the extreme luminosity range between sunlit areas and cloud shadows, it helps to use film with a wide exposure latitude. Low clouds and fog can make flying unsafe, and for most situations I recommend waiting for skies to clear.

It is possible to shoot under a completely overcast sky. Increase your angle of view and do not include the horizon in your photograph. Use a fast, high-contrast negative emulsion or push process transparency film to compensate for the low illumination and the flat lighting conditions. For certain architectural subjects, this lighting works quite well.

• Haze

Haze is the term for particulate matter and water droplets suspended in the air. It effects the aerial photographer more than any other atmospheric condition. The effect of haze on ground photography is usually negligible, but in aerial photography, where the image must pass through thousands of feet of air before reaching the camera, the effects can be devastating. Although worst in major metropolitan areas, it can be encountered anywhere. Haze can be produced by a number of factors, including water vapor, auto exhaust, industrial pollution, and airborne dust from farming operations. Water vapor and industrial pollution combine to produce what is generally referred to as smog (short for smoke and fog). The particles suspended in the air scatter the sunlight, lowering contrast and blurring scene details. By intercepting the light falling on the subject, the overall scene brightness is also lowered. The scattered light then illuminates the shadows and further reduces contrast levels. Because the effects are

Often the haze layer will only extend to an altitude of a few thousand feet. This is often the result of a temperature inversion.

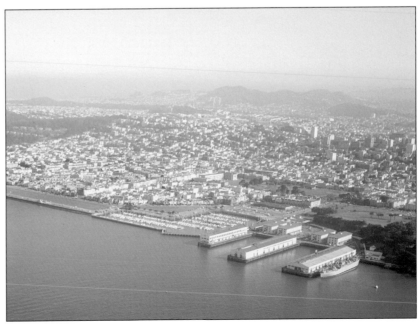

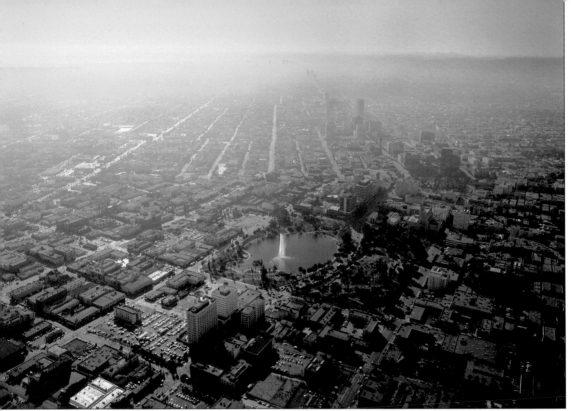

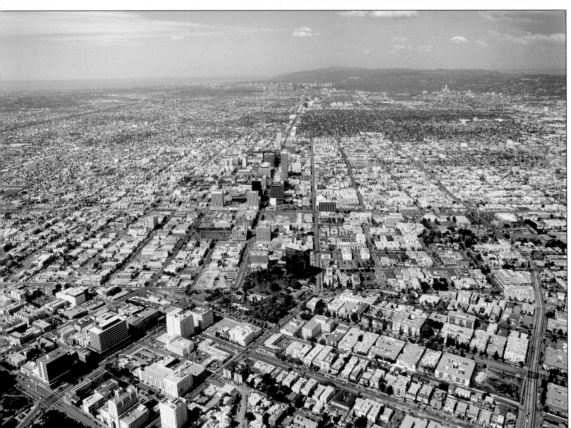

cumulative, distant objects can literally disappear due to hazy conditions.

Climate can greatly affect the amount of haze in the air. The concentrations will increase during warm, windless days. Most types of haze will remain suspended in the atmosphere until a low-pressure weather front passes through the area. The resulting winds

"The best days for air clarity often occur during the winter months."

and the mixing of the atmosphere will help clear the air. The best days for air clarity often occur during the winter months. The passing of a storm front with a pool of cold air behind it will inhibit the formation of haze. Under these conditions, visibility can exceed 50 miles and result in what is known as a "severe clear" day.

Often the haze layer will only extend to an altitude of one or two thousand feet, leaving blue sky above. This can make evaluating the severity of the haze from the ground fairly difficult. A good way to judge the amount of haze present is to hold your hand up and block out the blue portion of the sky. What color is the horizon? Is it white? Brown? How far can you see? Can you see detail in distant objects? Filters can help reduce the color shift produced by haze, and there are ways to compensate for the reduction in contrast. There is, however, no remedy for the lowered resolution and resulting loss of detail. If visibility falls below ten miles, photography may have to be suspended until skies clear.

If you cannot wait for better conditions, here are a few tips to improve your images:

Avoid backlit situations which will highlight the haze. It will help to arrange your flight so you will be shooting with the sun at your back.

1. **Avoid backlit situations.** The sunlight will highlight the smog particles, causing an increase in brightness and washing out the blue of the sky.

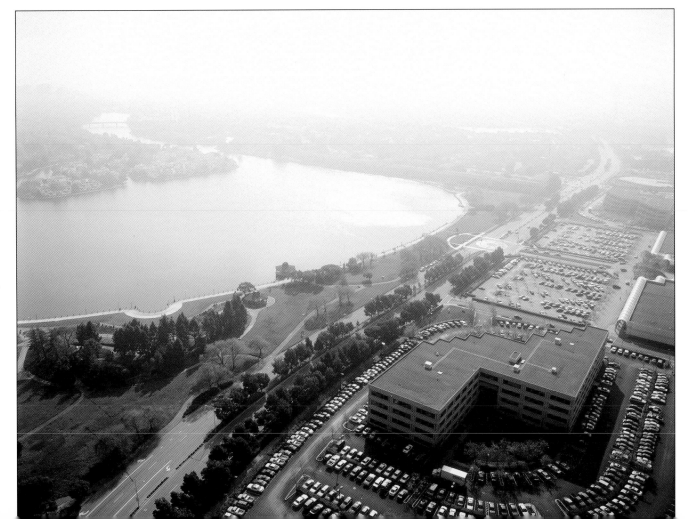

2. **Shoot early.** It can help to shoot in the morning hours while the atmosphere is cooler.

3. **Shoot late.** Late afternoon winds created by the day's heat can help to clear the air.

4. **Stay close.** Stay close to your subject and avoid a distant horizon line or far off objects.

☐ Water

The glare of light reflecting from water presents a problem familiar to all photographers. Most use a polarizing filter to reduce glare; however, this is often impractical for aerial photography. Because these filters must be adjusted to the angle of the reflected light, they can be difficult to use in a moving aircraft where your angle is constantly changing. You avoid this problem when using a helicopter, but in a fixed wing aircraft it is often simpler to remove glare by altering altitude or camera direction. Any reflection conforms to the law of physics which states that "the angle of incidence equals the angle of reflectance." In our case, the angle of the sun would be the angle of incidence and our camera angle would be the angle of reflectance. By changing the camera angle, you alter the angle of reflectance and thus change the angle of incidence. This works in most situations. However, on windy days, glare produced by small wavelets on the water can be extremely difficult to avoid. Often it is necessary to choose a time when the angle of the sun is low, such as early morning or late afternoon.

"... light reflecting from water presents a problem familiar to all photographers."

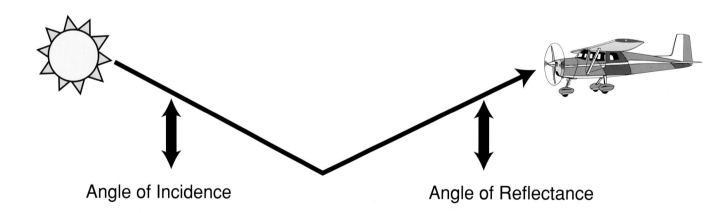

Angle of Incidence Angle of Reflectance

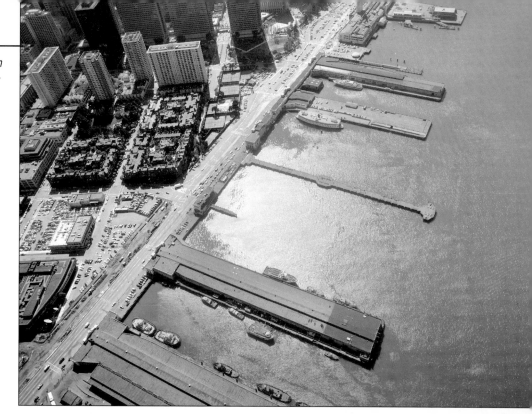

Glare from water is a common problem in aerial photography (top). A change in altitude or subject orientation can help (bottom).

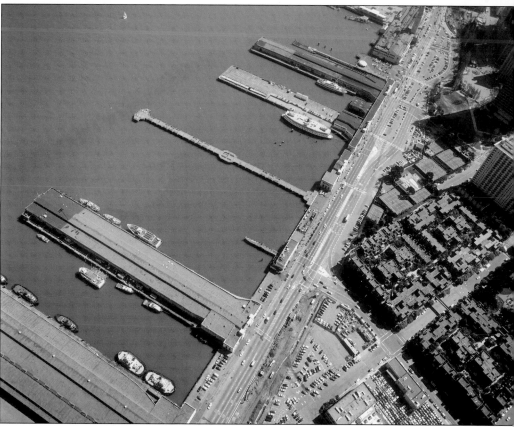

☐ Buildings and Cityscapes

Time of day and time of year play an important role in the photography of buildings in general. In aerial photography, the time of day is critical in determining when sunshine will illuminate the face of a building. Many times a ground inspection must be performed before the flight to assess the optimum time for photography. In urban areas, the time of day and the time of year will

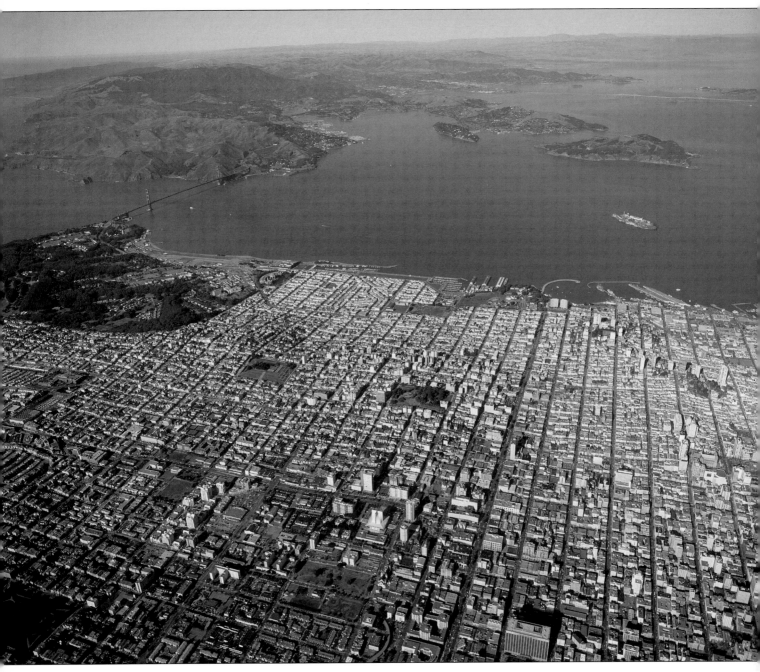

affect which streets are illuminated and which lie in shadows. In large cities, you may need to shoot as close to midday as possible to minimize shadows from tall buildings. Streets in many urban areas are laid out on north/south east/west grids, allowing you to easily determine shadows with the help of a map or a city plot outline.

• Building Materials
Certain building materials, such as all-glass office towers and highly reflective roofing materials, require aerial photographers to pay careful attention to avoid glare. Remember to always remain aware of every element visible in your viewfinder. The glare reflecting off objects will shift as your relative motion

Above. A low morning or late afternoon sun can be used to bring out subject texture.

Opposite. Certain subjects, such as this urban canyon view, are best shot close to mid-day to avoid distracting shadows.

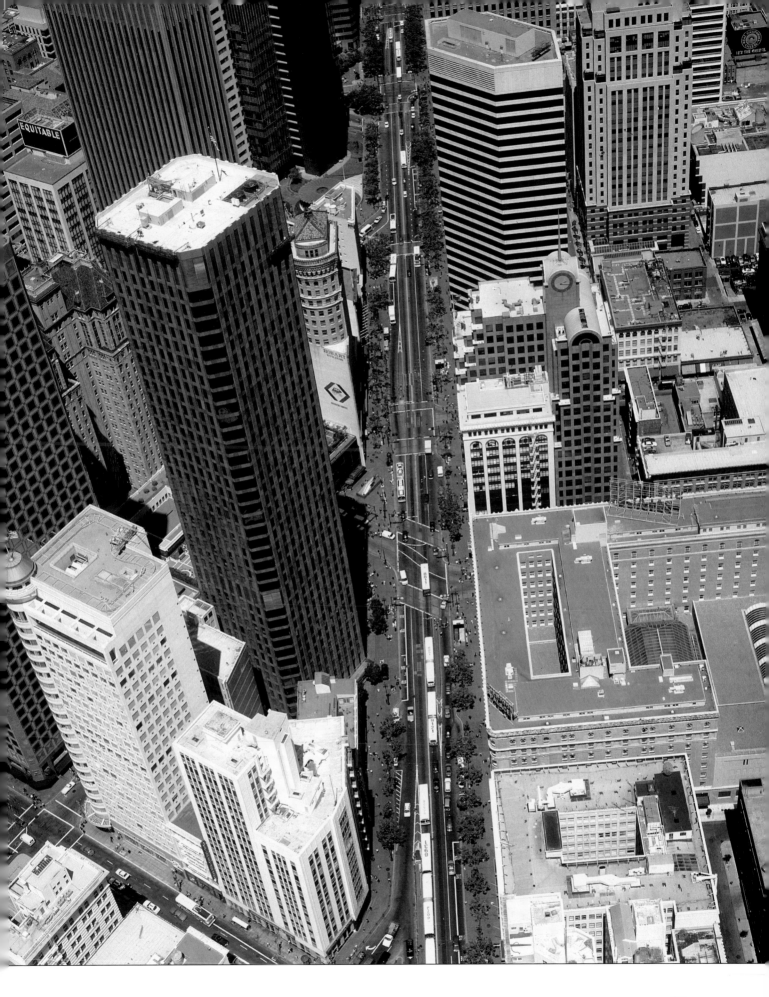

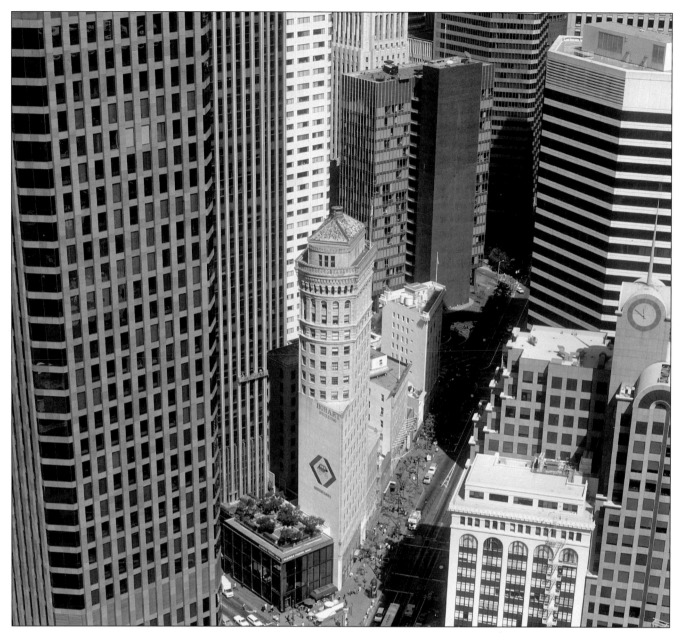

changes the viewing angle. It's easy to focus on your primary subject and miss the distracting glare from the tin roof across the way. In general, glare from buildings can be approached using the same techniques useful for dealing with glare from water.

The reflective properties of some buildings can benefit the photographer. Glass and light colored material can reflect sunlight and add illumination to courtyards and walkways. Glass office buildings (in particular those constructed of dark toned panels) sometimes benefit from the inclusion of select reflections, which adds interest to what would otherwise be a flat expanse of featureless glass.

Some subjects may only be free of shadows at a certain hour of the day, or time of the year.

When shooting a golf course, try to consult a layout of the course and its oreintation with the sun before you fly to determine the best time for photography.

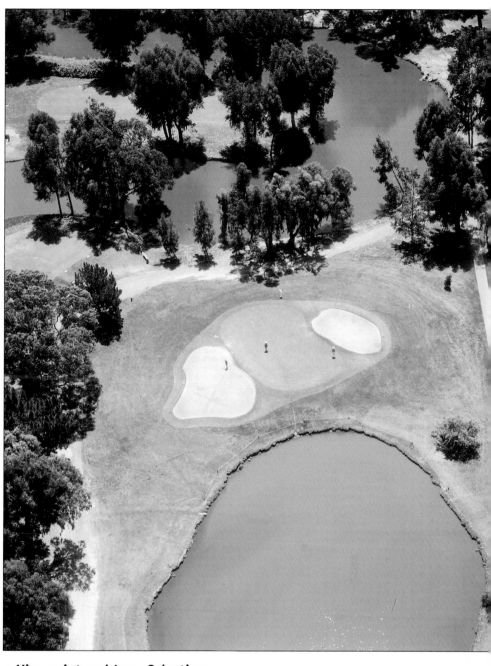

"... lens selection can dramatically alter the look of a cityscape."

• Viewpoint and Lens Selection

Camera viewpoint and lens selection can dramatically alter the look of a cityscape. A wide-angle lens will provide a panoramic skyline, while a normal or a telephoto lens can be used to isolate buildings and accent form and shape. A telephoto lens also helps when the photographer is forced to photograph small buildings from a high altitude. Use a long lens, pull back from the subject, and decrease the angle of view. This will allow you to photograph more of the building's face and less of its roof.

☐ Foliage

Forests and large areas of foliage present a special set of problems to the aerial photographer. The reflective properties of vegetation can vary wildly not only from species to species but throughout

the year as the growing season progresses. Many trees and shrubs (especially when grouped in mass) act like a light sponge, soaking up sunlight and reproducing extremely dark. In aerial photography, the shadows cast by leaves are usually hidden beneath the plant, but a low angle of sun or a back light situation will cause them to become apparent. Because of these types of problems, camera angle and time of day are very important. Forested areas should be photographed with as much frontal lighting as possible. During winter months when the angle of the sun is low, try to shoot landscaped areas from 11:00 till 1:00 to minimize shadows.

A polarizing filter is sometimes useful when photographing large areas of vegetation. By removing the surface glare (stray beams of light reflected from the leaf surface), these filters facilitate an increase in the saturation of colors recorded on the film. However, special care should always be taken when photographing foliage through a polarizing filter. The reflected light helps raise overall tonal value, and without it the leaves can reproduce abnormally dark. Also, because sharpness is a function of contrast, you sacrifice some edge detail when compressing the tonal range.

Sometimes surrounding trees and foliage may obscure a vital part of the subject to be photographed. This occurs mainly when photographing buildings or heavily wooded areas. In these situations, a photographer may be forced to wait until fall when the trees have shed their leaves and the subject is exposed.

> "... camera angle and time of day are very important."

During the summer months, leaves on the trees would have made this shot impossible.

MOTION 3

Image motion is always present in aerial photography and can be classified into three separate types which are of concern to the photographer. The first and most obvious is the forward motion of the aircraft relative to the ground. The second is the vibration of the airframe itself, which is caused mainly by the aircraft engine and aerodynamic forces. The third are sudden movements caused by updrafts and downdrafts of air. Usually produced by thermals, they are often encountered when flying over hills or along coastal bluffs.

■ Solving the Problem of Motion

The basic solution for most types of motion is to use a fast shutter speed. Although it is possible to shoot at extremely slow speeds by using a gyrostabilizer, a shutter speed of 1/125 sec. or higher is recommended. Many cameras today can achieve shutter speeds of 1/1000 sec. and above, which are sufficient to stop all but the most violent movements.

An advantage of aerial photography over other types of photography is the small depth of field requirements. Because the distance from the aircraft to the subject is usually quite far, the camera will normally be focused on infinity. Although shooting with a wide-open lens is not recommended, nothing will be gained by stopping down to a high f-stop. A wider f-stop allows the use of a faster shutter speed, helping to stop motion. For most aerial photography, the lens should be stopped down one to two stops from wide open and the focus locked on infinity. The settings can be taped down with a piece of gaffer's tape to avoid the risk of accidentally changing the settings during flight.

In practice, it is often surprising how slow a shutter speed can be used before producing unacceptable blurring of the image. Here

"... the camera will normally be focused on infinity."

are a few tricks to help you minimize the effects of motion in your images:

- Change the direction of the aircraft or the subject orientation. A course moving away the subject, or one approaching head-on, produces a reduction in the relative motion between the subject and the aircraft.

- If the subject itself is in motion, such as a car or a plane, match the speed and direction of the subject.

Although usually avoided in aerial photography, motion blur can be used for effect or to achieve a certain look. Using a slow shutter speed while hovering in a helicopter will remove the relative ground motion of the camera, keeping the background sharp, yet blurring a subject in motion.

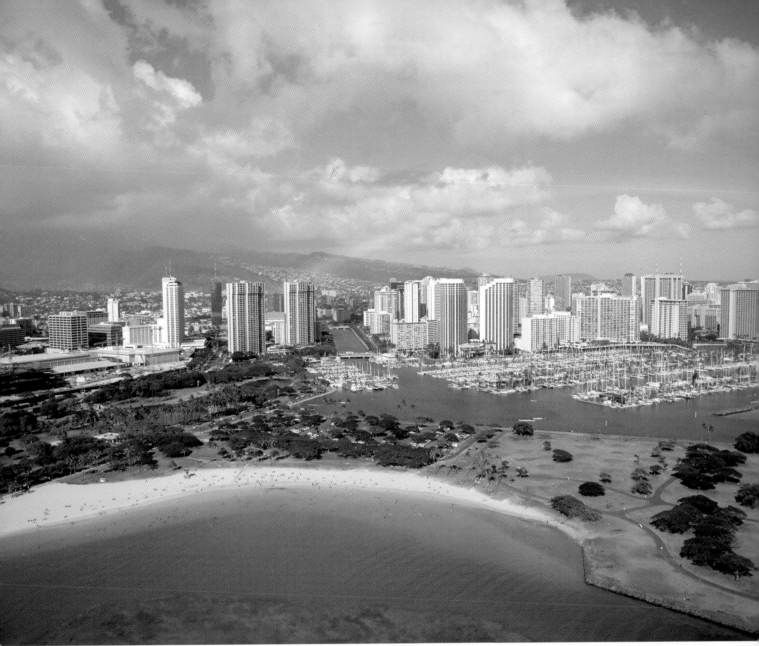

Although careful planning can increase the odds of success, certain photographs, such as this rainbow in Hawaii, result from being in the right place at the right time (above).

Usually occurring during late summer, the famous San Francisco fog is a somewhat predictable weather condition (right).

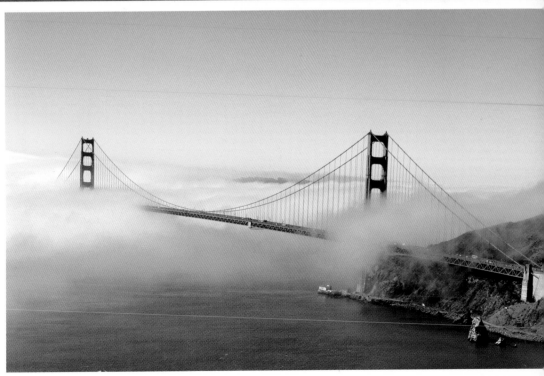

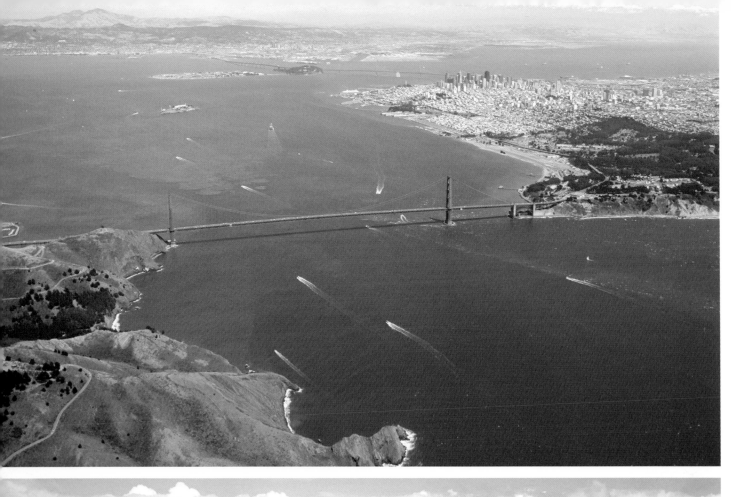

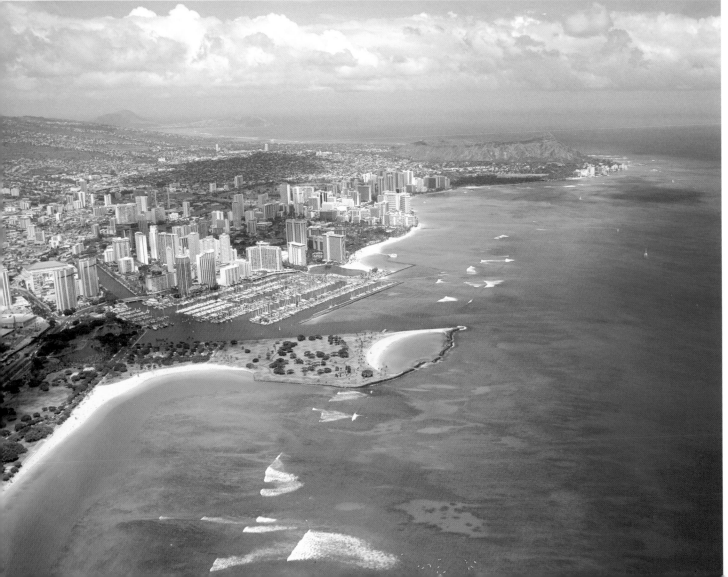

A fixed wing aircraft is the platform of choice when shooting from a high elevation (opposite, top).

A slow speed film, such as ASA 100 is the first choice for most subjects. It was used to capture this aerial image in Hawaii (opposite, bottom).

The repeated design and the colorful colors of the cars make for a classic stock photography image (below)

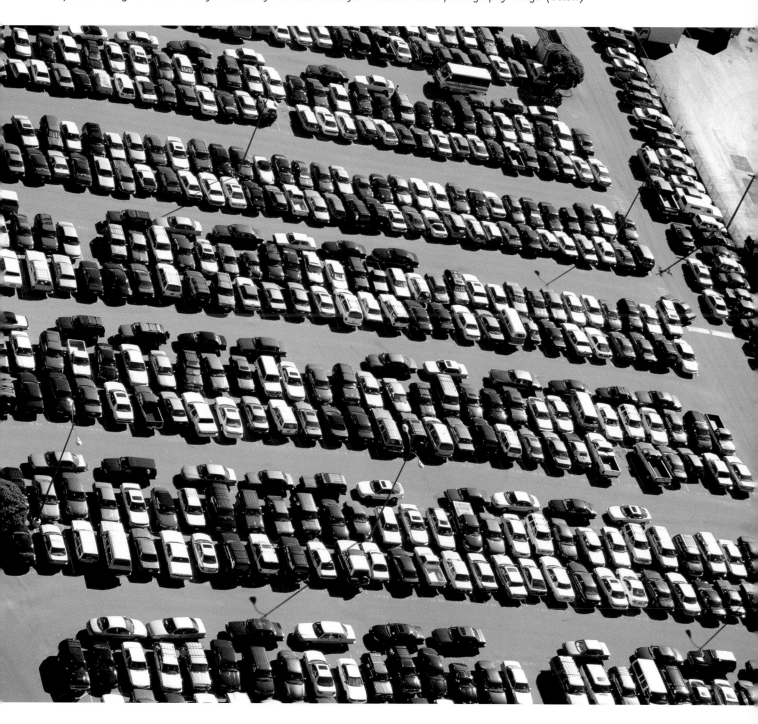

The uniqueness of the aerial view is the basis for these abstractions of nature.

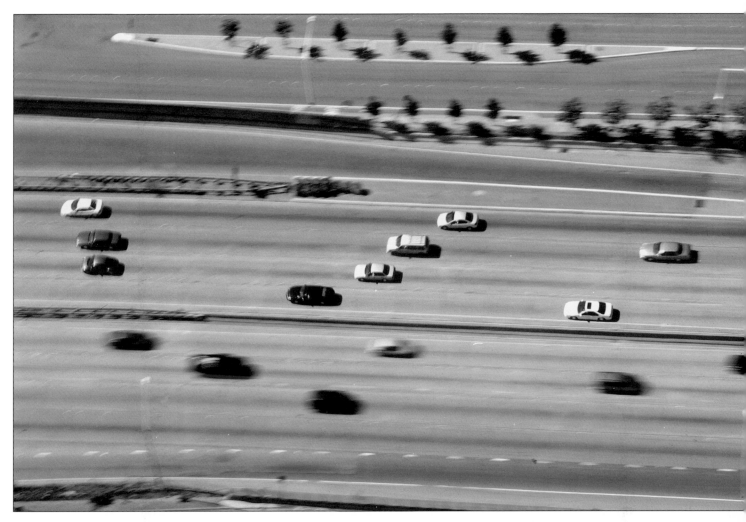

Cars traveling the same speed and direction as the camera are sharp due to a low relative ground motion. The relative motion of cars traveling in the opposite direction is increased, causing extreme blurring.

- Do not touch the aircraft. The first instinct of many photographers is to steady the camera by bracing against something. However, in an aircraft, this results in the transfer of vibrations to the camera through the photographer's body.

- Use a faster film or "push" process to achieve a higher shutter speed. Many transparency films can be pushed as much as three stops above normal. If possible, run a snip (test roll) to determine the exact processing times.

- When photographing from a plane, reduce the airspeed as much as possible. The pilot will know the particular stall speed for the aircraft and current flying conditions.

- A helicopter will allow you to hover in place; however, the additional strain on the aircraft can cause an increase in vibrations. It is best to always keep some forward motion, however slow.

- A gyrostabilizer should be used if absolute sharpness is required. Although somewhat expensive, they are available for rent at many camera stores.

The effect of ground movement on image quality decreases as the altitude increases. A similar effect can be seen while riding in a car. When looking out the side window, objects that are farther away seem to move much slower than objects nearer to the car. The apparent ground motion is also affected by the angle of view and the lens selection. This effect becomes more pronounced the longer the focal length of the lens.

Under certain conditions, the combination of aircraft motion and the direction of travel of the exposure curtain in a camera can produce a blurring of the subject. Extremely rare, it requires a very high rate of motion relative to the subject and a scan travelling in the opposite direction relative to the aircraft. To achieve high shutter speeds, many cameras use a scanning slit to expose the film. Rather than entirely open and close the curtain in a short time span, they partially open to produce a window which is panned across the film to expose the image. To check the direction of your shutter, open the camera back, point the camera at a light source, and trip the shutter.

> "...apparent ground motion is affected by the angle of view..."

To position a helicopter for this viewpoint requires flying the helicopter sideways (or "crabbing") at the same speed as the subject. By matching the speed of the ship, this maneuver will help maintain image sharpness.

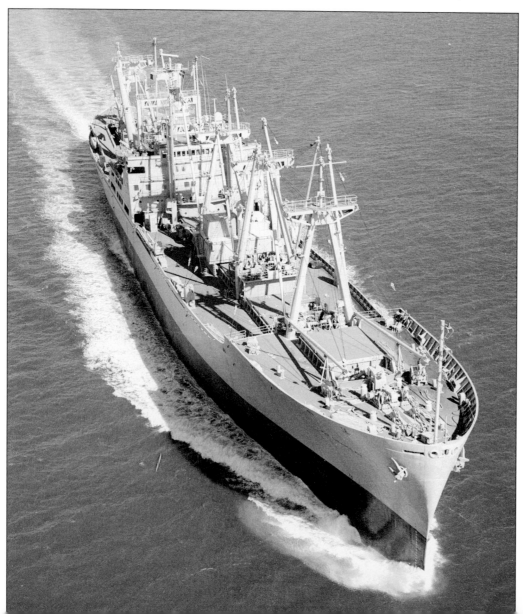

CAMERA SYSTEMS 4

Photography has significantly advanced since Nadar's day, when the wet plate process required a complete darkroom in the sky. Lightweight cameras and fast films have made photography from the air easily accessible.

In fact, cameras have progressed to the point that many of the latest features and functions are not needed. Automatic exposure meters and auto-focus systems can become confused by the aerial environment and may supply false information. A simple 35mm camera with a single lens, compact enough to easily be carried aboard a small plane, is all the equipment needed to capture stunning aerials.

Due to advances in film technology and reproduction techniques, 35mm cameras and films are more than adequate for many subjects.

Housing Subdivision
Walnut Creek, CA

(c) 1996 RICHARD ELLER

■ Beyond Simple Snapshots

However, if you plan to go beyond simple snapshots of your travels or to pursue aerial photography on a professional level, there is a vast array of equipment available to make your job easier and raise the quality of your photography. A basic set-up for professional photography would consist of a camera capable of shutter speeds of 1/500 sec. or faster, a normal, a wide angle, and a telephoto lens, plus a polarizing filter and a haze filter. An extra camera body is also recommended for use as a back-up.

Both 35mm and 120mm film formats are suitable for low

FORMAT	PROS	CONS
35MM SYSTEMS	Small, lightweight, and compact; they are easy to operate in the physical confines of aircraft cockpits. Motor drives are readily available for most systems. Plus, the 35mm format provides more exposures per roll than 120mm.	A small viewfinder size makes tracking objects more difficult. The smaller film size limits the amount of detail recorded and the maximum reproduction size.
120MM SYSTEMS	A large viewfinder makes through-the-lens viewing easier. The larger film format allows for greater detail and reproduction sizes larger than 35mm.	A larger size and weight makes for increased difficulty of operation in confined spaces. Fewer exposures per roll mean more frequent film changes.

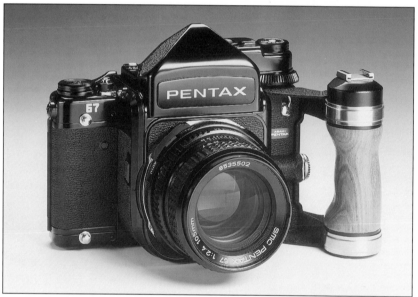

Many professional aerial photographers, including myself, use the Pentax 6x7 for aerial photography.

level aerial photography. The chart above lists the strengths and weaknesses of each.

Panoramic cameras are also available and produce sweeping landscapes with angles of view greater than 90 degrees. Two models in particular are well-suited to aerial photography. These are the Fuji G617 and the Linhof 617S. Both use 120mm film to make 2 $^1/_4$" x 6 $^3/_4$" pictures without the distortion that a wide angle lens would produce. Beware of pan cameras that use a rotating lens or slit-scan shutters to expose the film. The forward motion of the aircraft can produce blur in the image. A helicopter is the recommended platform when using a panoramic camera.

It is recommended that you carry a selection of lenses of various focal lengths, from a wide angle to a medium telephoto. This will save valuable airtime by not having to reposition the aircraft when

"Beware of pan cameras that use a rotating lens or slit-scan shutters..."

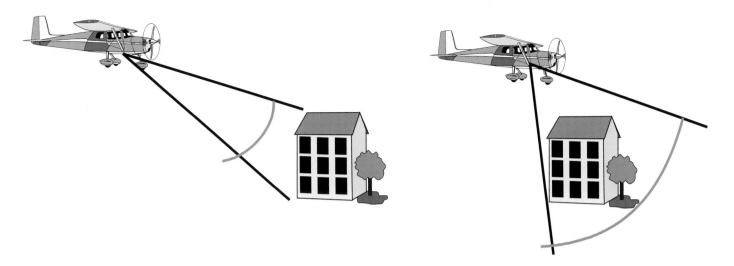

Moving closer in a linear direction, or gaining altitude will increase the angle of attack. Pulling back in linear direction, or losing altitude will decrease it.

switching views. Remember, because you are working in a 3D environment, physically moving the camera closer to the subject does not equal switching from a normal lens to a telephoto. To move from one camera position to another and still maintain the same viewpoint, you must change altitude. This is due to the fact that you are not shooting from the same level, but at an angle from above your subject. Therefore, unless you compensate by lowering altitude, your angle of attack increases the closer you approach. This can be used to your advantage.

Focal lengths longer than 3x normal for the film format are not recommended due to the increase in vibration transmitted to the camera. If a long lens is required, it is often easier to use a teleconverter. These fit between a camera body and a lens, effectively doubling the focal length. Compact and lightweight, they are much easier to transport than an additional lens. When shooting with a long lens from a moving aircraft, take extra care not to allow the end of the lens barrel to enter the slipstream outside.

◼ Metering for Aerial Photography

Most times an exposure meter is not necessary. The clear air and nearly cloudless skies needed to produce quality images make basic exposures easy to estimate. However, there are times such as early morning or late afternoon when a meter can be helpful. Be sure you understand what your meter is reading and how it arrives at the recommended exposure. Is it a spot? A center average? A multi-point average? This information can be found in your camera manual. The restricted angle of view and the ability to isolate subjects make the spot meter the first choice for aerial applications.

Photo Tip:
When photographing small buildings, use a long lens and pull back to reduce the angle of attack. This will allow you to show more of the buildings' face and less of the roof.

□ Filters

In general, low level aerial photography (below 5,000 ft) does not require special filtration to achieve acceptable color rendition. Resolution loss and the additional exposure required to compensate for the filter may outweigh any positive benefits. The two filter types listed below can be useful under certain conditions. Remember that image sharpness is critical in aerial photography, so buy the highest quality filter you can afford.

• Polarizing Filters

Polarizing filters are both a blessing and a curse in aerial photography. They can be extremely helpful in removing glare and can dramatically increase the color saturation of blue skies and green vegetation. They accomplish this by removing the stray reflected light, allowing only light that is correctly oriented with the filter to pass. However, it can sometimes be difficult to maintain optimum orientation from a moving aircraft, and the 1 to 1 $1/2$ stops of additional exposure required is sometimes unavailable. It helps to use a TTL or in-camera meter to determine the correct exposure. Choose a film with a wide exposure latitude and watch carefully through your viewfinder for the desired effect.

"Polarizing filters are both a blessing and a curse..."

• Haze Filters

Haze filters consist of two components. One absorbs the ultraviolet spectrum of light to counteract the increase in UV radiation. The second component adds yellow to compensate for the color shift to blue. Most valuable at altitudes above 5,000 ft, their usefulness for low level work is somewhat limited. Although they correct for color shifts, they do nothing to restore the loss of subject detail caused by haze. Haze filters designated for aerial use come in three grades: H1A; H2A, and H3A. Do not confuse them with common ultraviolet or UV filters. Simple UV filters are not effective for aerial photography.

• Step-Up/Step-Down Rings

Available in a variety of sizes, step-up and step-down rings allow the photographer to use the same filter on various diameter lenses, thus helping to save the space and the expense of separate filters for each lens. Stepping up the lens diameter to a larger size filter works best. Be careful when stepping down; too large of a correction can cause vignetting of the image.

□ Additional Camera Equipment

• Motor Drive

Standard on many 35mm cameras, and available for some 120mm systems, a motor drive is a valuable asset for aerial photography. Anything that makes shooting faster and easier is helpful when photographing from an aircraft in motion.

• Gyro Stabilizer

Consisting of a gyroscope (which attaches to the tripod socket of your camera) and a battery pack that is usually worn as a belt, this accessory allows for photography at very slow shutter speeds. The spinning gyroscope acts as a vibration damper and provides camera steadiness. Because it does not counteract the motion of the aircraft, it is best used in a helicopter where relative ground motion can easily be controlled.

• Additional Film Backs

Additional film backs are available for almost all 120mm format cameras. Pre-loading extra backs saves time and makes it easier to change film while in flight. Some backs can be removed mid-roll, which is helpful when shooting with multiple film types.

• Pentaprism

Many 120mm cameras are designed primarily for studio use and come equipped with a waist-level viewer as standard equipment. These can be awkward to operate in the cramped confines of many airplane cockpits. Adding a pentaprism, or eye-level viewfinder, will greatly increase functionality.

• Grips

Pistol grips, which attach to the tripod socket, and handgrips, which attach to the side, greatly increase the steadiness of a hand held camera. They also make it more comfortable to hold larger 120mm format cameras for extended periods of time.

• Camera Bags

Like any location shooter, an aerial photographer's camera bag is almost a home away from home, packed with everything one may possibly need while in the air. However, weight and space is always a consideration when flying, so try not to overload. Look for a bag that conforms to the airline association guidelines for carry-on luggage of 22"x14"x 9". To the left is a list of the standard contents of my bag.

◾ Additional Gear

• Gaffer's Tape

There is a common misconception that duct tape and gaffer's tape are the same. They are not. Lighting technicians (gaffers) in the movie business developed gaffer's tape to stick to most surfaces and, most important, to leave no adhesive residue when removed. I use gaffer's tape on my camera to lock down exposure and focus and place a small strip on the buckle of my safety harness to protect against an accidental release.

• Compact Binoculars

A pair of compact sport binoculars with a wide angle of view can

PACKING LIST

Camera Equipment
Two bodies
Wide angle lens
Normal lens
Telephoto lens
Film
Polarizing Filter
Haze Filter
Step-up/Step-down Rings
Lens Cleaner and Tissue
Blower Brush
Notepad and Pens
Fine Point Permanent Ink Marker
Spare Camera Batteries
Gaffers Tape
Compact Screwdriver Set
 (regular and phillips head)
Swiss Army Knife
Needle Nose Pliers
Filter Wrench
Spare Eyeglasses
120mm Take-up Reel
Nasal Decongestant and Aspirin
Band-Aids
Two Large Zip-Lock® Plastic
 Freezer Bags

be extremely helpful when locating subjects from the air. It can be surprising just how hard it can be to locate something from above. The housing project that looked so large and unique on the ground can disappear from a few thousand feet up.

• GPS Systems

Global Positioning Systems use satellite transmissions to determine the exact location of the receiver anywhere on the planet. Small hand-held units are available that are accurate to within a few feet. They are not only useful when attempting to locate a remote location, but, when coupled with a city map, can be used to locate street addresses too.

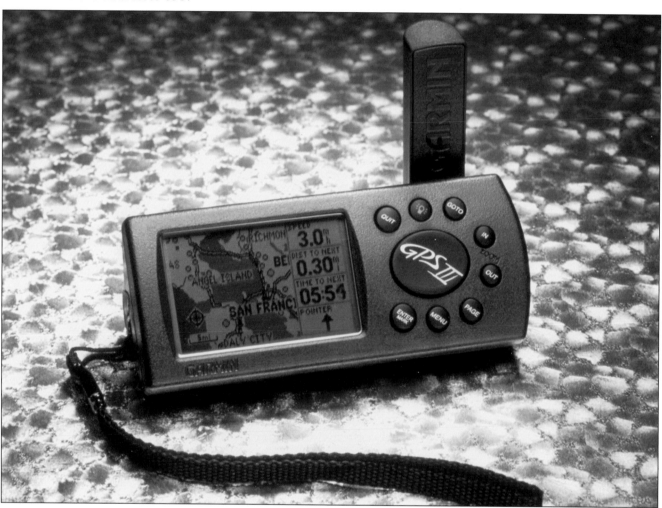

A hand-held GPS receiver can be helpful in finding specific locations from the air.

• Glasses

Due to the increase in the intensity of sunlight at higher elevations, a pair of sunglasses or other UV coated eyewear is recommended. Try to purchase a pair with cable style earpieces that wrap around the back of the ear to provide extra security. If you wear prescription eyeglasses, it is advisable to carry a second pair in your camera bag. A pair of clear safety goggles, available at most hardware stores, can be helpful to protect your eyes from the airflow.

A photo vest with large, easily accessible pockets can be extremely useful in the cramped confines of many aircraft.

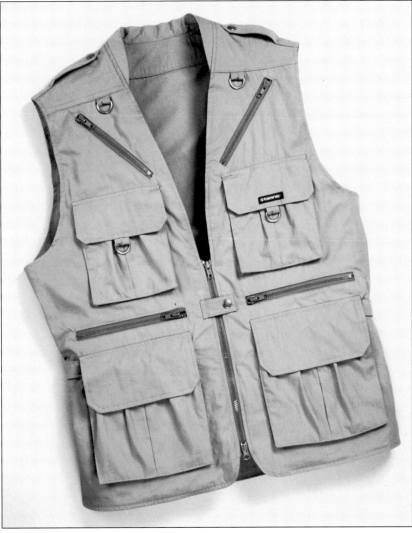

"... a warm jacket or coat may be needed..."

• Clothing

A photographer's vest or an aviator's jacket with large front pockets works nicely to keep film and gear handy, as well as helping you avoid extraneous movement in cramped cockpits. Depending upon the weather, a warm jacket or coat may be needed, especially during winter months. In a helicopter, with the door removed for photography, the wind chill factor, plus the temperature drop from the increase in altitude, can cause dramatic changes in temperature. A pair of photographer's gloves, the type with removable fingertips, is recommended for cold weather shooting. To make your own, take a pair of leather gloves and cut off the fingers about halfway to the tip. However, stay away from wool or similar materials; the lint they shed can blow into your camera while loading film and cause problems.

FILM CHOICE 5

In aerial photography, basic film choice is a question of positive or negative and hi-speed or slow. Accurate skin tone and critical color reproduction are not normally a consideration. It is advisable to purchase professional grade films to insure consistency of color and exposure. Keep track of the expiration date and the emulsion number printed on the film box. Slight variations in the manufacturing process can cause color shifts from batch to batch, so try to use only one emulsion per flight.

A slow speed film is the first choice for aerial photography due to the need to achieve as much image detail and sharpness as possible. For general use, a 100EI rated film will be fast enough to provide an exposure of 1/1000 sec. at F5.6 in bright sunlight. This is short enough to freeze motion and still be an F-stop or two from wide open. Shooting with a wide open lens is not recommended due to the effects on sharpness; however, there is never a need to stop down more than one or two stops. Depth of field is not an issue in aerial photography because everything is far enough away from the camera for the focus to be set on infinity.

In general, choice of film speed will be determined by the weather conditions, and choice of film type of will depend upon the end use of the image.

▢ Film Speeds
• Slow Speed Film (EI100 to 160)
The fine grain of slow speed film translates into increased sharpness and detail to allow for maximum enlargements. This should be your first choice for use in bright sunlight conditions.

"A slow speed film is the first choice for aerial photography..."

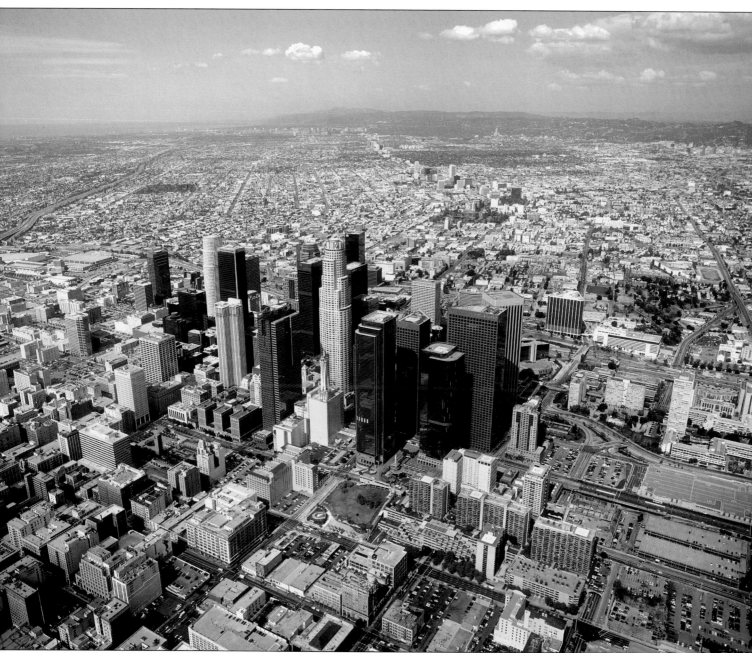

A slow speed film, such as the ASA 100 film used for these images, is the first choice for most subjects.

• High Speed Film (EI400 and up)

The increased speed and higher contrast is helpful in overcast or low light situations. A high contrast film can be beneficial when photographing from high altitudes.

☐ Film Types

• Positive Film

Positive (transparency) film is easy to push/pull process, which allows for adjustment of the exposure and contrast to cover a variety of situations. The long tonal range makes transparency films the best choice for high resolution image scanning as well as the preferred film of most stock photography agencies.

• Negative Film

A wide exposure latitude makes negative film an excellent choice for changing lighting conditions. A negative film is also the best choice when prints are required.

• Infrared Film

Infrared films are sensitive to the infrared spectrum of light, making them useful in recording information that cannot be captured with conventional films. Developed for the military to distinguish the difference in the infrared reflectance between camouflage and live vegetation, they are now used for a variety of forest and crop survey projects. The three light sensitive layers of the emulsion are set to record green, red, and infrared instead of the red, green, and blue of normal film. In addition, all three layers are

Many stock companies will only accept subjects photographed with transparency film.

sensitive to blue and ultraviolet radiation, requiring that exposure be made using a #12 deep yellow filter. To avoid fogging, it is recommended that the film be loaded in total darkness.

Many films are now offered in two varieties: normal color for exposure in sunlight, and a slightly warmer version for exposure in open shade. While the former is preferred for most situations, the warmer color reproduction of the latter can help when photographing under overcast or hazy conditions.

Most professional photographers buy large amounts of the same emulsion and test that particular batch for color and exposure. The film is then stored in a refrigerator to retard the aging process. If stored in the freezer, film will stay fresh almost indefinitely. To avoid condensation, remember to allow the film to return to room temperature before opening.

"Many films are now offered in two varieties..."

EXPOSURE 6

In aerial photography, as in most outdoor photography, the amount of the sunlight illuminating the subject determines exposure. The intensity of the light is effected by four factors: atmospheric conditions; distance from subject; time of day, and time of year. Because professional aerial photography requires a relativity clear day and the amount of sunlight for a given time of day and year is predictable, exposure values can be determined beforehand to improve your chances of having a successful shoot.

■ Determining Exposure

In general, basic exposures for low level aerial photography conform to the "F16" rule, which states that "the exposure for outdoor photography in bright sunlight will equal 1/film speed @ F16. For example, the exposure for a film with an EI of 125 would be 1/125Sec. @ F16. In aerial photography, where a fast shutter speed is more important than depth of field, this would convert to a setting of 1/1000Sec. @ F5.6. With the exception of winter months and early morning or late afternoon, this setting will provide properly exposed film. Under clear skies, with a solar angle of 30 degrees or greater, exposure values will vary no more than 1/4 to 1/3 stop, easily within the latitude of modern film emulsions.

Determining exposure under cloudy or overcast conditions is more difficult. The thickness and amount of cloud cover can vary widely and change rapidly from location to location. However, most conditions call for no more than 1/3 to 1/2 stop correction. In conditions with a mix of bright sun and cloud shadow, it is best to set exposure for the sunlit areas to avoid overexposure. Deep shadows cast by clouds can be a special problem. Not only can the brightness range from sun to shadow exceed the reproduction latitude of certain films, there can also be a loss of con-

"Deep shadows cast by clouds can be a special problem."

trast and detail in the shadow area itself. The major illumination these areas receive is from light scattered by the atmosphere, with a small amount of reflected light from clouds. This flat, omni-directional light further reduces the brightness range and contrast. Because the light is universal rather than directional, object edges are de-emphasized and contrast and apparent sharpness are further reduced. Increasing exposure cannot compensate for this loss.

The same problem exists, although on a smaller scale, when photographing under overcast skies. High, thin, cirrus clouds can act as a scrim, allowing light to pass through but reducing intensity

Clear, cloudless, haze-free days like these make it easy to pre-determine exposure values.

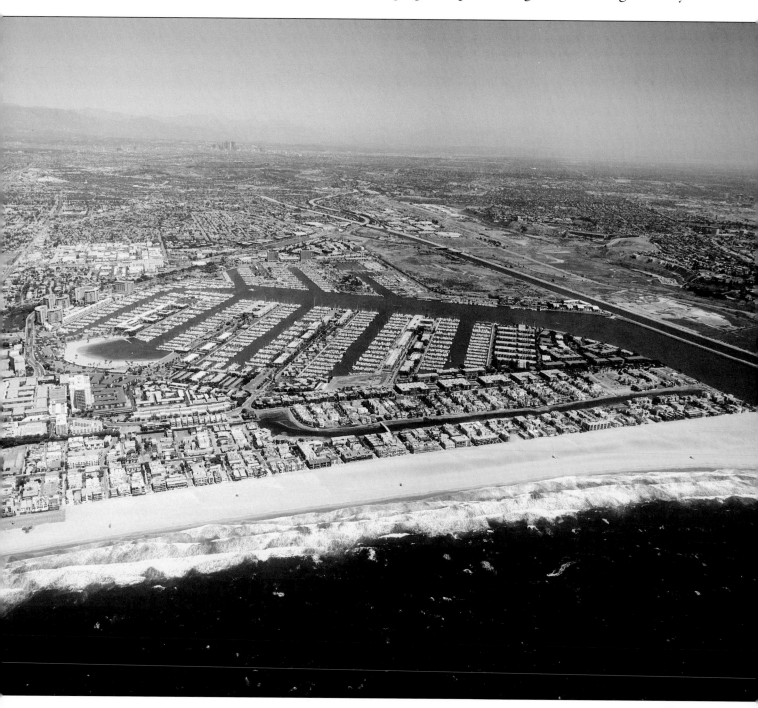

and softening shadows. Unless the cloud cover is particularly thick, exposure values need not be increased more than 1/4 to 1/2 stop from normal.

Haze is another situation where an increase in exposure will not restore image detail lost from the scattering of sunlight by particles suspended in the air. However, it is possible to compensate for the reduction of contrast by film choice and push processing.

Because the areas of shadow cast by clouds are illuminated by scattered, unidirectional light, the loss of detail cannot be compensated for by increasing the exposure.

☐ Snip Tests and Test Rolls

When shooting transparency film, many photographers like to bracket to insure a proper exposure. This can be difficult in aerial photography, where each frame is slightly different in composition due to the motion of the aircraft. A better solution is to run a snip test or process a test roll to determine the proper exposure values and then adjust the processing time for the remaining film. Exposure should be decreased by 1/3 to 1/2 stop when shooting at altitudes above 5,000 feet. The higher the altitude, the

> "This raises the overall brightness while lowering contrast."

more atmosphere there is between the camera and the subject, which increases the scattering of light. This raises the overall scene brightness while lowering contrast. In addition, the increase in altitude causes areas of light and shadow to shrink both in size and in visual importance, further reducing the apparent scene contrast. It helps to slightly underexpose the film and then push process to increase contrast.

There are times, such as early morning, late afternoon, or when shooting under completely overcast skies, when an exposure meter is the best way to determine proper exposure. The limited angle of view of a spot meter works best by isolating the subject when a reading is taken. When using a center weighted meter, try not to include a large amount of sky. Heavy haze or shooting from a high altitude can also cause false readings, as can backlight situations and glare. The wide exposure latitude of modern negative emulsions will cover most situations. However, if there is any doubt, run a snip test first to determine the proper processing times.

Sometimes a subject, such as this shot of San Francisco through the fog, will require careful metering.

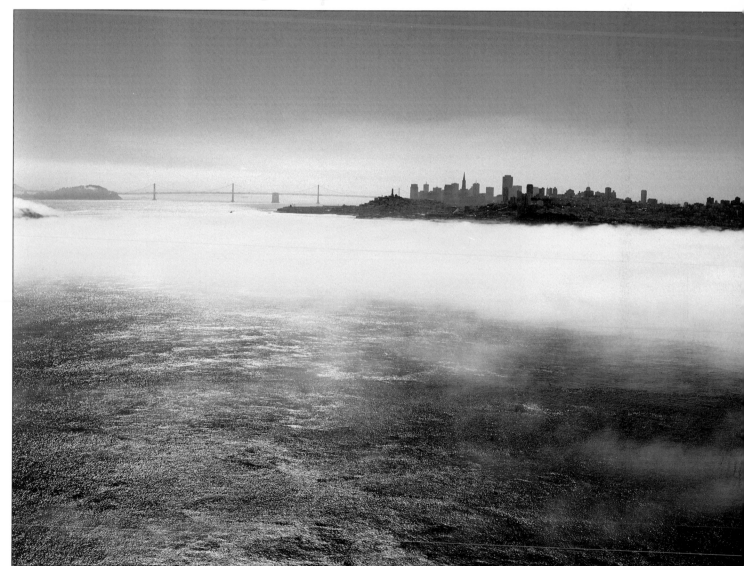

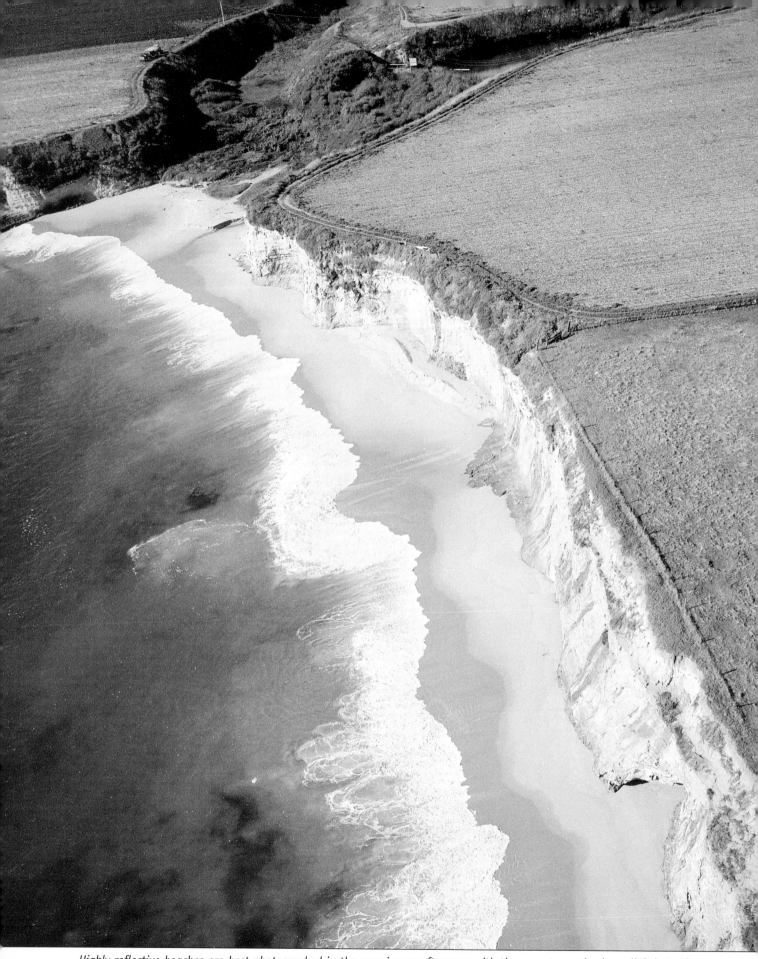

Highly reflective beaches are best photographed in the morning or afternoon with the sun at your back or slightly to the side.

PREFLIGHT PLANNING 7

Preflight planning is essential for the success of any photo flight. Time spent preparing will help eliminate unpleasant surprises and insure a safe and rewarding experience. The first step in preflight planning is determining the purpose of the flight and what type of photograph is required.

◼ Determining Your Objectives

The normal objectives for most aerial photography flights can be reduced to four questions: what, where, when, and how?

• What is the Subject?

Understanding your subject is the first step in successful flight planning. The subject of the photograph will determine the overall requirements of your flight. Suitable aircraft, lens choice, film selection, time of day, and the basic flight plan are all dependent upon the type of subject to be photographed. The amount of surrounding area that must be included will determine lens selection and flight altitudes. Will the image be a close-up view of the subject or a wide-angle view to show the surroundings? Is it important to show highway access or to include a local landmark to help identify the location? How large of an area must the photograph show? By defining the subject and the context in which it must be shown, the necessary viewpoint and the equipment required will become clear.

• Where is the Subject Located?

Subject location is another important consideration. Areas may have limited access, with flight restrictions on the available airspace. Certain restricted areas may require the use of a helicopter to gain access. Terrain and distance to the nearest airport are also considerations.

"Understanding your subject is the first step..."

Sometimes an assignment will serve more than one purpose. Although originally commissioned as construction progress photography, a final shot was added for use on the cover of a brochure and for a postcard.

OCEANSIDE

Water Pollution Control Plant

Joint Use:
Being A Good Neighbor and
Protecting the Environment

DEPARTMENT OF PUBLIC WORKS, CITY AND COUNTY OF SAN FRANCISCO

Certain locations, like this photograph of the San Francisco International Airport, require permission for flight access.

• When Must the Photography be Completed?

Are there time constraints on the photography? Some images, such as a ship entering a harbor, are a one-time only event and cannot be easily repeated. Others, like construction progress photography, must be completed by a certain date.

• How Will the Photograph Be Used?

A four-color brochure or an 8"x10" glossy photograph? Web use, or a wall mural? The end use of the photograph is important in making film choices and assignment pricing. General composition decisions, such as the choice between vertical or oblique formats, are also affected by the intended use of the image and the purposes it was created to serve.

Preflight planning is also the time to determine any special needs or requirements. These can include special formats, like a

panoramic camera, or unique mounts, such as a gyrostabilizer. Certain assignments may require specific weather conditions or times of day to achieve the desired lighting. Consult a map of the general area and a solar table to determine the optimal time and direction for photography.

☐ Flight Restrictions

Applicable flight restrictions on altitude and relevant traffic control areas must also be determined before flying. In populated areas, the FAA requirements for fixed wing aircraft state that "all planes must maintain an altitude of 1,000 feet above the highest object or building within 2,000 feet horizontally." The minimum height for unpopulated areas is 500 feet. All of the aforementioned altitudes are stated as AGL (above ground level) measurements. Helicopters, however, do not have a minimum height requirement, making them useful for low-level work. The only requirement is that the altitude be "reasonable and safe."

Traffic Control Areas are locations where aircraft flight is restricted. This can range from total exclusion to having flight allowed only at select altitudes. A typical TCA (Class B) airspace may limit flight to altitudes either below 2,000 feet or above 10,000 feet to keep the airspace between reserved. These restrictions occur most often around large metropolitan airports or military installations. TCA's are not usually a problem, although certain areas may require the use of a helicopter. Always call the tower ahead of time to arrange for clearance. "Pop-ups," or appearing on the air traffic controllers' screen unannounced, is likely to result in permission being denied. Flight maps showing the flight regulations for your area are available at most aviation supply stores and flight schools.

☐ Weather: Predicting the Unpredictable

Weather conditions are perhaps the single most important factor for successful aerial photography. But how do you plan ahead for something as potentially unpredictable as tomorrow's weather? You need to know not only if it will be safe to fly, but also if the conditions will be acceptable for photography. Will skies be clear, or will the clouds continue to build? While at times it may seem impossible to predict, tracking changing weather conditions for the purposes of aerial photography is not excessively difficult. The secret to learning to "predict" the weather is to gather information from as many sources as possible.

Although an understanding of cloud formations and a knowledge of what changes in the barometric pressure signify can be helpful, today's technology provides a wide variety of sources for weather information. They include television, radio, the Internet, and the telephone.

"Traffic Control Areas are locations where aircraft flight is restricted."

"A major source of weather information is television."

In the tropics, the weather can vary widely and change rapidly from location to location.

• Television

A major source of weather information is television. Local news and most national morning news shows broadcast weather predictions for the next few days. If you are lucky enough to have more than one local station, watch several and compare the forecasts. Try to get a feel for how accurate the individual meteorologists are over a period of time, and then stick to watching one you feel is most often on the mark. Many cable companies also broadcast the Weather Channel, which provides a three-day local forecast plus a seven-day national outlook.

• Radio

The advantage of radio as a source of weather information is mobility. Broadcasts can be heard at home, in your car, and most anywhere via small portable radios. Special "weather" radios are also available that provide the official National Oceanic and Atmospheric Administration forecast. The information provided by the N.O.A.A. is the basic data that is used by most local weather forecasters.

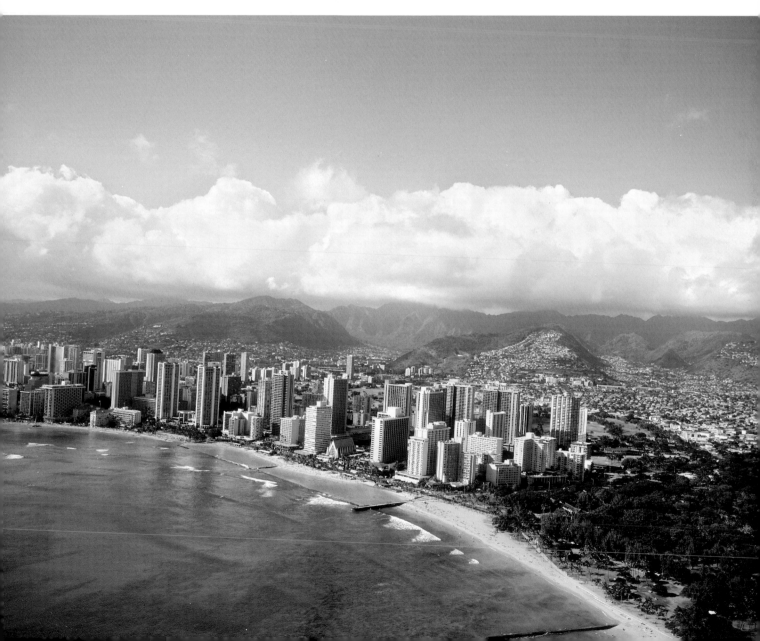

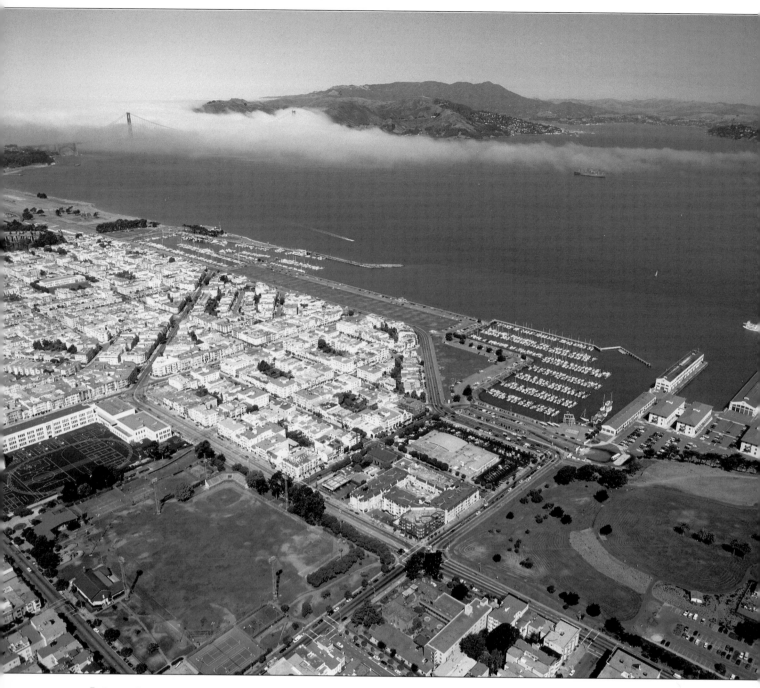

• Internet

The Internet is fast becoming the prime source for weather information. Entire websites devoted to the weather provide more information, and in more detail, than is accessible through any other medium. Many aviation websites provide weather information as well. The multitude of webcams appearing on the Internet are another valuable resource. These provide a "real time" look at current conditions at each camera's location. Many newspapers now also publish an Internet edition. These can be particularly useful when trying to track the weather at a distant location for an out-of-town assignment.

The client wanted the Golden Gate Bridge visible, so I waited almost a month for the fog to clear enough for this shot. Even then the fog did not completely clear the coast.

Because no time was available for a re-shoot, I circled quite a long time waiting for the clouds to part and the sun to illuminate the subject.

• Telephone

Among the many dial-up weather services, perhaps the most valuable is the Air Traffic Information System (ATIS). If you are a pilot, you are already very familiar with this system. Available by telephone, the ATIS is not a forecast but a report issued by the tower that gives the current weather and airport conditions at the specified airport. This report is updated hourly or sooner if there is a significant change. Much of the information, such as runways in use and departure patterns, is of interest only to the pilot. However, among the current weather conditions listed are the amount of cloud cover, cloud ceiling, wind speed and direction, the visibility in miles, and the dewpoint. It helps to listen to at least three updates to obtain a feel for the current weather condi-

tions and how rapidly they are changing (See Appendix A: How to Read a ATIS Report).

By combining the forecasts from a number of sources and tracking the current conditions the day of the shoot, the weather can be predicted fairly accurately. Always remember that the farther in advance a prediction is made, the less accurate it becomes. Being able to forecast the weather and predict the outcome of changing conditions are valuable tools for successful aerial photography.

"... the farther in advance a prediction is made, the less accurate it becomes."

SELECTING THE AIRCRAFT

8

Available in a variety of shapes and sizes, many aircraft are suitable for aerial photography. From fixed wing aircraft to turbine powered helicopters, your choice will largely depend upon image requirements unless your options for available aircraft is limited. In general, a helicopter is preferred for low-level work (below 1000 ft) and when working in high traffic or restricted areas. When working from altitudes above 3,000 ft, a fixed wing aircraft is best. Both are usually available at most municipal airports. Along with charter services, many flight schools and flying clubs can provide a plane and a licensed pilot.

◼ Fixed Wing Aircraft

The majority of all aerial photography is taken from fixed wing aircraft. It is possible to take photographs from most airplanes, but models with a high wing design, such as a Cessna where the wing is situated above the cockpit, are the most conducive to successful photography. The Cessna 150, 172, 182, and 210 series are economical, have room for a passenger, and are readily available at most airports. It's no wonder the Cessna is the most commonly used platform for aerial photography.

The major problem with utilizing small planes for photography is the intrusion of the wing tip, the strut, or the landing gear on the camera's field of view. This can result in a reduction in the number of usable sightlines. If possible, use an airplane equipped with retractable landing gear. These are usually designated RG, as in 172RG. This helps by removing the wheel from the bottom of the camera frame and greatly improves downward views. If your plan is to photograph a vertical format, then an RG aircraft is a must. Even better is a plane such as a Cessna 210, which has retractable landing gear and no wing strut.

"It is possible to take photographs from most airplanes..."

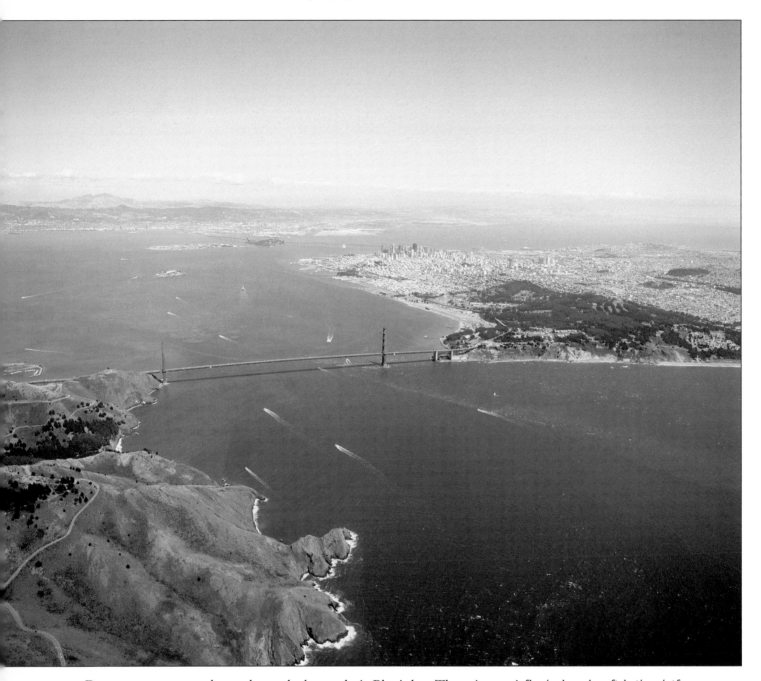

Do not attempt to shoot through the cockpit Plexiglas. The windows are not optically clear and often contain a slight color tint that will effect your photographs. Before take-off, verify that the window opens on the side of the plane from which you will be photographing. Locate the metal strap, which connects with the airframe, on the forward edge of the window. Using a screwdriver, remove the screw which attaches the strap to the window frame. This will allow for the window to be fully opened. Close the window using the interior latch before take-off. Remember to save the screw and to reassemble the window after the flight.

Once airborne and over the subject, unlatch and open the window. It should sit nestled tightly under the wing, held open by the airflow. To keep the airflow under the wing as clean and

A fixed wing aircraft is the platform of choice when shooting from a high elevation.

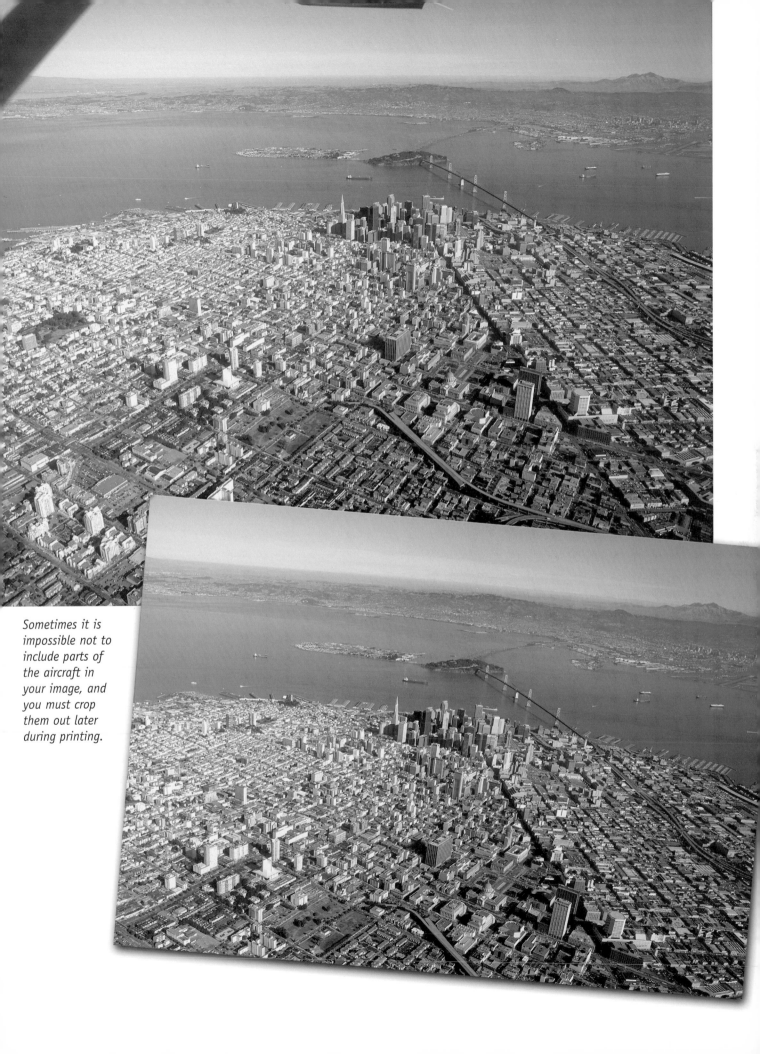

Sometimes it is impossible not to include parts of the aircraft in your image, and you must crop them out later during printing.

unbroken as possible, have the pilot use the throttle (and not the wing flaps) to slow the speed of the aircraft.

Some planes, such as those used for skydiving, are flown with a door removed to provide a large portal for photography. When shooting from an open doorway, a harness restraint is recommended for safety. A line, long enough to allow mobility but short enough to provide security, should be attached to the seat belt anchors or similar bolts in the airframe.

Here are a few tips to keep parts of the aircraft you are flying in from showing in your photographs:

- Use a lens with a narrow angle of view. If your photograph needs to show a larger area, try increasing your altitude instead of switching to a wide-angle lens.

Below: Be careful not to include the propeller in the photograph. It may not be visible in the viewfinder, but it will be apparent in the final image. Although the image could be cropped, a better solution would be a long lens with a narrower angle of view.

Opposite: A helicopter is the best aircraft for photographing small buildings or when a close-up view is needed.

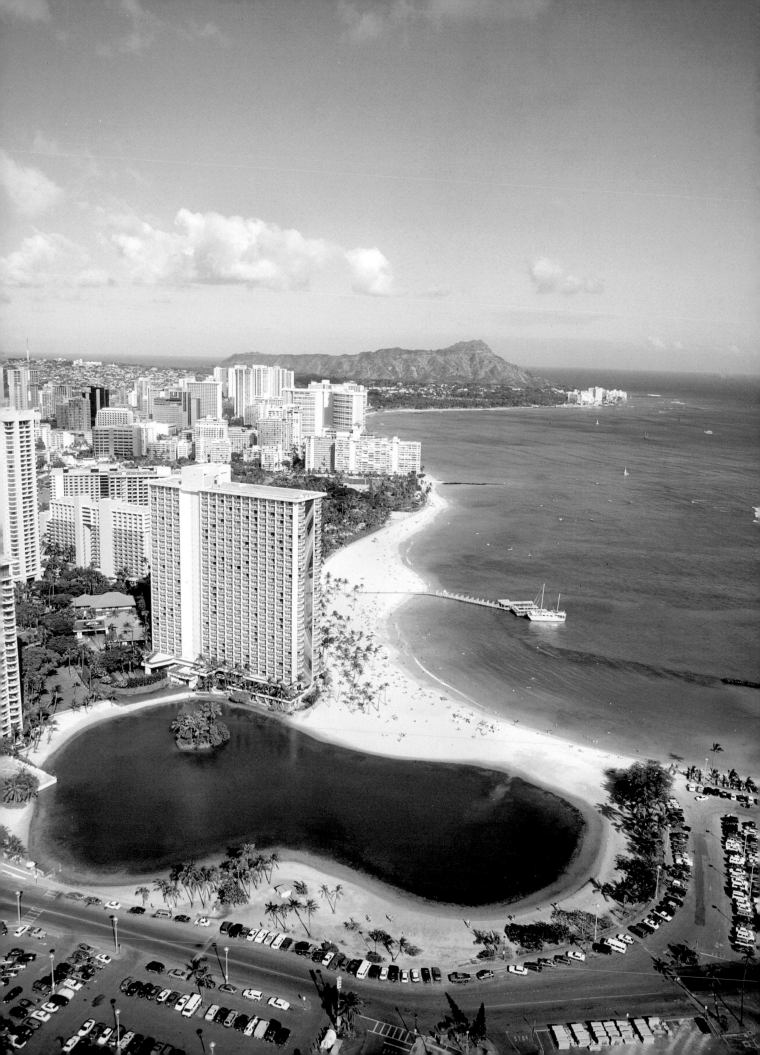

- It is possible to shoot through the forward quadrant between the propeller and the strut. Use a lens with a narrow angle of view and keep your view away from the nose of the aircraft and the propeller. Although you will not see it in your viewfinder, the fast shutter speed will freeze the spinning prop and cause it to show in your photograph.

- The best sightlines are from the rear quadrant between the strut and the tail. It helps to have the aircraft turning slightly and moving away from your subject.

- The placement of the strut makes it difficult to simply fly-by on a course parallel to the subject. A better course is to approach the subject at a slight angle. Have the pilot execute

A helicopter is the best aircraft for photographing small buildings or when a close-up view is needed.

a flat turn away from the subject upon reaching the point of photography, using the rudder and keeping the wings level.

☐ Helicopters

For many subjects, helicopters provide the ideal platform for aerial photography. Usually flown with the door removed, they offer a wide, unobstructed view that is unhampered by wings and struts. The ability to move in almost any direction or to stop and hover in position, makes positioning the aircraft easy and saves expensive airtime.

When shooting from a helicopter, make sure you and your equipment are tightly secured, and take extra care not to drop anything out the open door when changing lenses or film. Be especially careful with film wrappers and other pieces of paper. If caught in the tail wash, they can be sucked into the rotor blade and seriously damage the aircraft.

This control panel, from an Engstrom, is typical of those found in most helicopters.

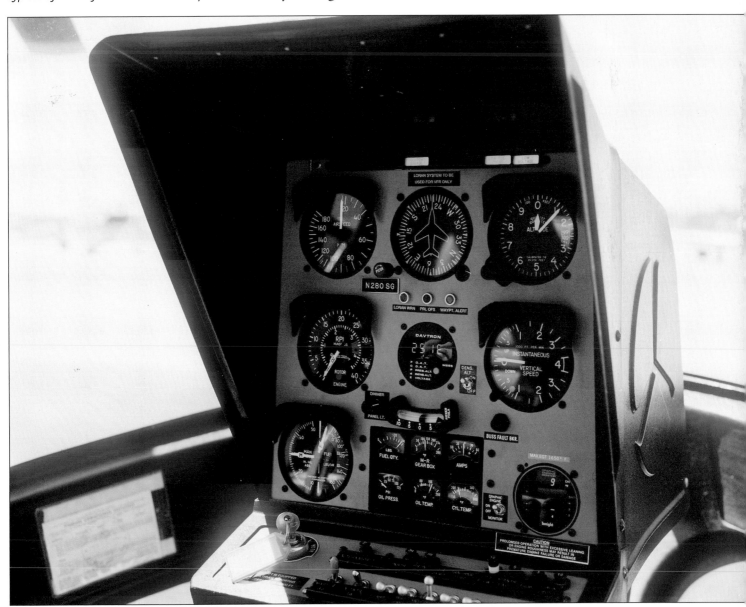

Many small helicopters have extremely cramped cockpit conditions. For these situations, a photo vest or a small camera bag for essential gear can be indispensable.

◻ Getting to Know Aircraft and Captain

Whatever aircraft you utilize, you should familiarize yourself with the control panel. Certain instruments are relevant only to the pilot; however, some provide information of value to photographer as well. Among these are: the altimeter, which gives the altitude; the compass, which shows the direction of flight; and the airspeed indicator, which displays the aircraft speed. During the pre-flight check, have the pilot point out the fuel gauges and explain possible warning lights or sounds.

Selecting the right pilot is also important. Whenever possible, fly with someone whom you have flown with before and know to be a capable pilot. Piloting an aircraft for purposes of aerial photography requires highly developed flying skills. Try to interview the pilot well before the flight to inquire about the subject area and previous experience flying aerial assignments. Always ask the number of hours of flying time that the pilot has accumulated, the number of hours logged in the type of aircraft you will be using, and the number of hours flown in the particular aircraft you will be flying. Pilots should have a commercial license and preferably be certified as a flight instructor (CFI) by the FAA.

One other system is commonly used as a platform for aerial photography. The use of blimps and other lighter-than-air vehicles predate the airplane and are still in widespread use today. Small ground-controlled blimps capable of attaining heights of 200-300 feet are used for extreme low level photography. Many modern systems come equipped with a video downlink to preview the image.

"Selecting the right pilot is also important."

FLIGHT TIME 9

"Sometimes waiting can work to your advantage..."

On the day of the flight, the first item to check is the weather. Because the atmosphere plays a key roll in the look and feel of a photograph, the decision between flying or waiting for better conditions is extremely important. Often, if you have been tracking the weather, the decision is simple. However, at times this can be extremely difficult. The four basic questions to consider when making a decision are:

- Is it safe to fly?
- Can the photograph be taken another day?
- Will the weather improve?
- Will the pilot and aircraft be available?

Certain subjects, such as a special event or a sporting contest, occur only at scheduled times and may require shooting under less than ideal conditions. Sometimes waiting can work to your advantage by allowing you to combine canceled flights (as well as taking off and landing only once), thereby saving valuable flight time.

▣ The Final Check
Double check to insure that you have everything you will need during the flight. Bring extra film along, not only for your intended subject but also for unplanned photographic opportunities you may encounter along the way. Always make sure that your gear is safely stored away in your bag and that your bag is secured, especially during take-off and landing. Stay "heads up," both inside and outside your aircraft, and pay extra attention to other nearby aircraft in operation. Remember, you are in a potentially dangerous situation every time you fly. Although the threat of serious injury is quite low, staying alert will reduce the risk even further.

Luckily, it was sunny when the employees of this company joined together to set a Guiness Book record for the World's Largest DNA Strand. Some assignments may have a very small window of time in which to shoot.

Take the time to familiarize yourself with the aircraft, especially if this is your first time flying in that particular plane. Fully brief the pilot on where you wish to fly and what you will be photographing, including any special maneuvers you may require. Always remember that it is the pilot who is responsible for flight safety and who has the final say on what can and cannot be attempted. Even experienced professionals can suddenly find themselves in a critical situation while attempting to capture the perfect shot. The same rules apply when dealing with air traffic controllers and airport towers. Do not argue if a request is denied. Your safety and the safety of others are their primary concern.

☐ Communicating with the Pilot

The best system for communicating with the pilot during flight is an onboard intercom equipped with noise canceling, voice activated headsets. This will allow you to talk directly to the pilot, helping to remove the aircraft noise in the background and making conversation easier. Test the system before takeoff and make sure you understand how it operates. Some aircraft, especially

"Fully brief the pilot on where you wish to fly and what you will be photographing..."

helicopters, require a button or floor switch to be activated before speaking. Be careful not to allow the microphone to enter the slipstream outside the aircraft during photography. To minimize the sound of the slipstream, position the headset so that the microphone arm is on the side of your body that is facing the front of the aircraft when looking out the side window. Before shooting, push the microphone down tight under your chin to help shield it from the airflow. Remember to reposition the microphone after pulling back from the window.

If an intercom system is unavailable, a set of basic hand signals should be established before takeoff. These will facilitate communication with the pilot without having to talk over the noise of

Be sure to carry extra film for shooting stock images and other photo opportunities.

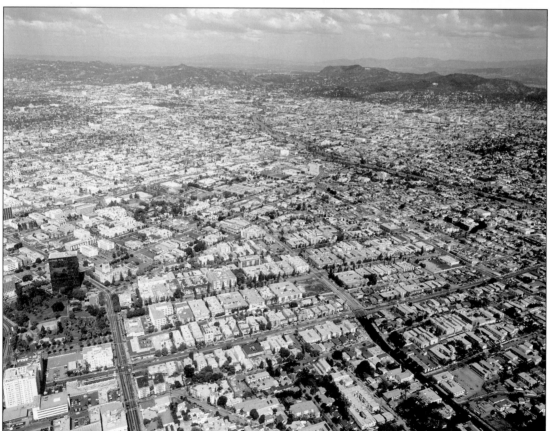

Some subjects (top) are easy to locate from the air, while others (bottom) may be quite difficult.

the aircraft or while your head is turned watching the subject. Establish simple gestures to cover the most likely situations, such as:

- Turn Left
- Turn Right
- Straight Ahead
- Circle and Start Again
- OK

In addition, a signal for "wings up" and "gear down" can be helpful to remove the aircraft from the edges of the picture frame.

Although a slanted horizon can add direction to an image (top), it is usually best to try to keep the horizon line level in the photograph (bottom).

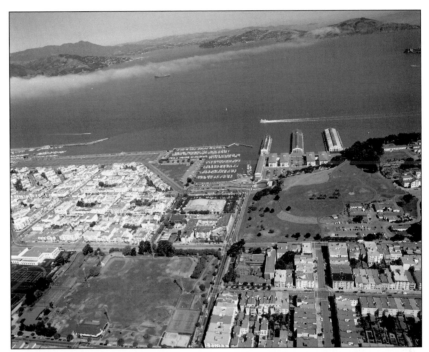

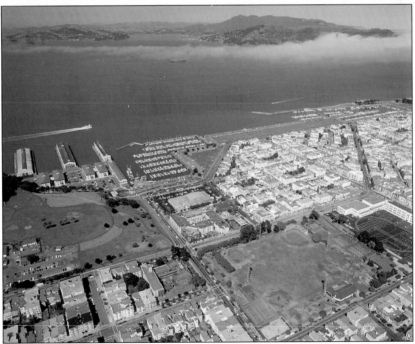

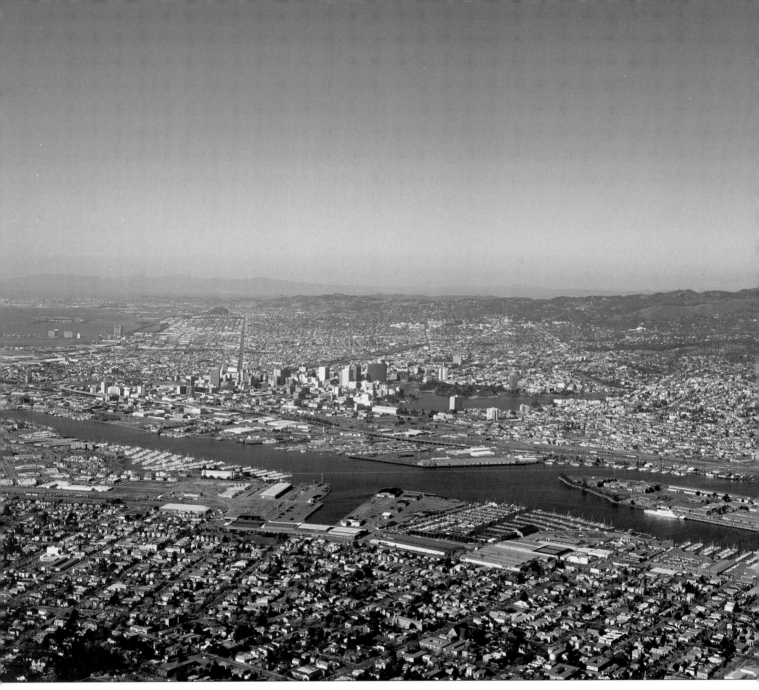

Be careful when using hand signals not to block the pilot's view or hinder his ability to fly the aircraft. If a headset is not used, a pair of earplugs can help reduce the level of ambient noise. Soft, inexpensive foam plugs are available at most airport aviation supply shops.

Another common mistake is to include too much sky in the composition.

☐ On Location

Upon reaching your destination, point out the subject, along with prominent landmarks and features, to help the pilot position the plane. In many small aircraft, the vision outside the cockpit is limited, and the pilot may not be able to see what you see from your side of the aircraft.

Keep your head, hands, and as much of your camera as possible inside the cockpit. Do not brace yourself against the window.

Instead, use your body as a shock absorber and isolate yourself from the aircraft. If you touch the airframe, you will transmit vibrations from the aircraft engine to the camera. While shooting, be careful not to accidentally lean out of the cockpit opening and enter the airflow outside the aircraft, especially when using a long lens. A plane or helicopter in motion can produce a strong slip-stream, most notably the airflow under the wing. It is this airflow that provides the lift for the aircraft and keeps it aloft.

Stay aware of the subject composition and framing. It's easy to focus on the subject to the exclusion of other areas of the photograph. Pay particular attention to the horizon line and the amount of sky showing in the frame.

Images like this general area shot showing highway access can be resold to a number of separate clients as stock photography.

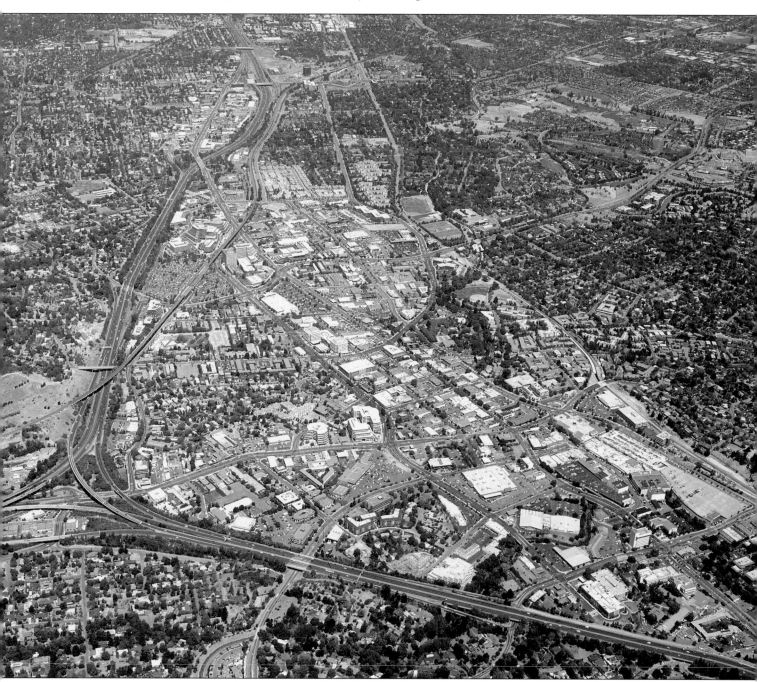

Be careful not to include parts of the aircraft (such as the wing or the landing gear) in the photograph, and watch out for the shadow of the plane that is cast on the ground by the sun. Depending upon the terrain, this shadow may show in your photograph. Sometimes distracting elements like this are unavoidable and must be cropped out later when a print is produced.

Don't be afraid to circle around and shoot a few extra frames. Tracking the complex and ever-changing composition offered from an aircraft in motion can make capturing the ideal frame difficult. It's better to use a little extra film than to return and attempt to re-shoot.

Although this applies to all aerial photography, it is especially true for assignment photography where airtime is a business cost. There are several reasons why it is always advisable to shoot a few extra frames when working for a client. First, it allows the photographer to pick the best frame during editing at the studio. There, images can be studied more closely for composition and design without the distractions of flying. Second, the photographer should save the "outtakes" and only deliver the final selections to the client. Then, should the original images be lost in transit or suffer damage, a back-up set will still be available. Shooting extra images also helps to protect against accidental damage during development. Process the film in separate batches, and always examine the first batch before processing the second. This also serves as a check on exposure and development times. Extra images are also valuable to the studio through stock and second market sales, and are useful for studio promotion and advertising.

> "... it is always advisable to shoot a few extra frames..."

BUSINESS 10

Selling aerial photography and flying for a living is a dream that many photographers and pilots have achieved. As a start-up business, aerial photography has a number of advantages: the up-front costs are low compared to other businesses; the equipment required is minimal and can be rented; and all the photography takes place outdoors, so a studio and lighting equipment are not needed. In fact, the entire business operation can be run from an office in the home.

■ Expanding Your Horizons

Professional photographers will find that aerial photography can increase the value and appeal of their studio to existing clients, as well as bring in new assignments. Markets such as architecture, annual reports, real estate, and stock photography all utilize aerial photographs, and the ability to offer both ground and aerial views is a powerful selling point.

Pilots who seek to derive income from flying face the added complexities of complying with FAA regulations. If the pilot receives any monetary compensation for the flight or from the sale of the photographs, a commercial pilot's license is required.

Performing aerial photography for business purposes raises the level of pre-flight planning required. It is very important that both the purpose and the intended usage be determined. The type of information that the photograph must provide and the composition that will best convey it become very important considerations. Certain assignments may require the photographer to scout the location beforehand to determine the best time of day and to insure that the subject can easily be identified from the air.

"Certain assignments may require the photographer to scout the location..."

Many real estate professionals purchase packages which consist of a ground view (left), a close-up aerial view (right), and a wide-angle view showing the surrounding area (opposite page).

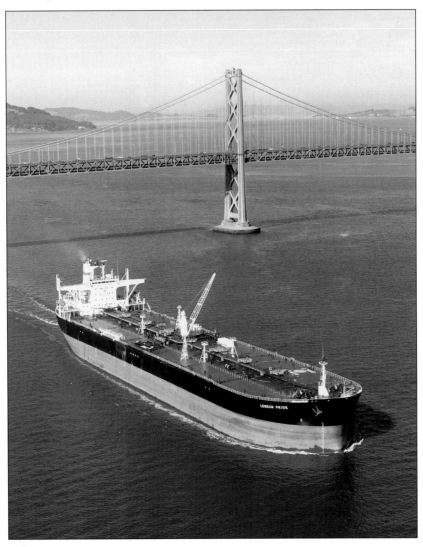

Some subjects, such as this oil tanker, are best captured from the air.

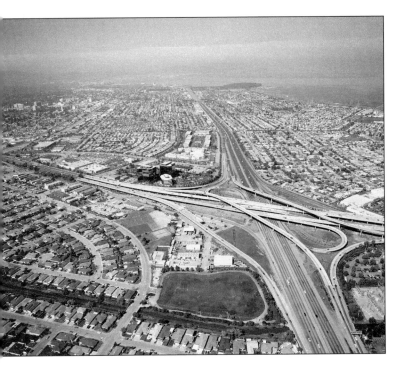

◻ Clients

The list of possible clients for aerial photography is quite long and grows longer every day. As the general public has grown accustomed to viewing images from an aerial perspective, the range of its uses has expanded. Once mainly valued for the information it provided, aerial photography is increasingly being used by advertising and mainstream media for the unique perspective it provides. Potential clients include the business sectors of advertising, graphic design, publishing, print media, construction, real estate development, real estate sales, property owners, roofing contractors, manufacturing facilities, and several sections of local, state, and federal government. Basically, a market exists for almost anything that can be photographed from the air.

There are several sources for obtaining information on possible markets. Contact names, addresses, and other information can be found in most business and trade directories. In addition, many trade associations and guilds publish a list of their members. These publications are usually available at the reference desk of the public library.

"The yellow pages are another good source of leads..."

The yellow pages of your local phone book are another good source of leads, as are newspaper articles and magazine stories. Trade magazines and other industry-specific publications can be particularly useful. Sources such as these will provide the information needed to create a targeted mailing list of potential clients.

Commercial mailing lists are available for purchase through various sources. By compiling the information and providing it in a ready-to-use format, a purchased list can save time and make marketing easier. However, many lists are old or otherwise out-of-date, which will affect the response rate. This can be particularly true in industries that have a high job turnover, such as advertising or publishing. All lists, both purchased and those privately complied, will need to be updated on a regular basis to remain current.

◻ Marketing

Advertising and marketing are keys to any successful business. Ads in the yellow pages and in targeted trade magazines, plus postcards and other direct mail pieces, should be designed to work together and reinforce the central message. Plan a market-

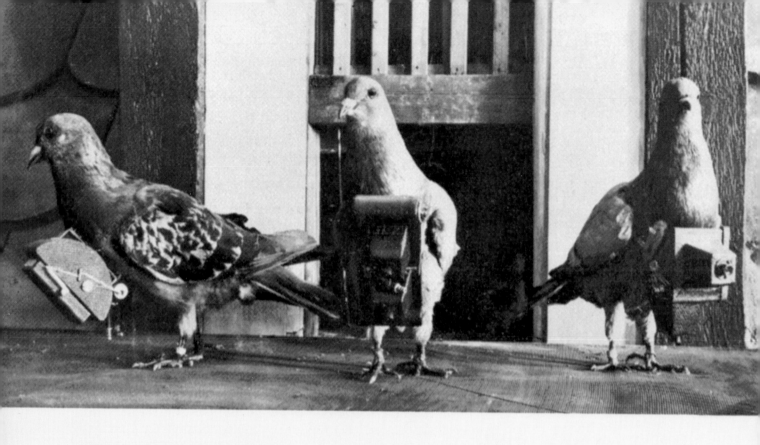

Tired of the Same Old Birds-eye View?

Sometimes humor is very effective in promotional advertising (top).

Mailings like this post-card (bottom), which is scored to punch-out for use as a Rolodex card, are a very cost effective form of promotion.

AERIAL IMAGES PHOTOGRAPHY

4560 19TH ST.

SAN FRANCISCO, CA

94114

415-553-8922

ing campaign and stick with it. Often the results will not be evident until months later when potential customers begin to call. All inquires that do not result in a direct sale should be re-targeted with a follow-up phone call.

Always include your current clients in your marketing efforts. They, and the referrals they bring, will provide a solid foundation from which to grow. The best customers are repeat clients and referrals that often come "pre-sold" on using your services.

◻ Pricing

Developing a fee structure for your services can be a complex task. The geographic area of operation, client demand for a given style of photography, and personal reputation all play a part. Additionally, the largest portion of the time required to complete an assignment is often not spent in the air, but on the ground before and after the flight. Locating the subject (either by scouting the location or by using a map), tracking the weather, scheduling an aircraft and pilot, driving to and from the airport, and processing, editing, packaging and delivering the completed job can consume most of the day. With the exception of scouting the location on the ground, none of this time is directly billable to the client. Time spent purchasing film and other supplies would be a similar non-billable expense.

To derive a base price for assignments, begin by estimating the total number of billable days in a year. For aerial photography, this means the number of days when the weather and other conditions are acceptable for photography. Subtract a few days for a brief vacation and other personal holidays, and the result is the total number of billable days. Other time may be spent running the business, but it does not produce a direct profit return for the studio and should not be included.

Next, add up all the expenses required to operate the studio for one year to compute the total overhead costs. This would include office, car, telephone, advertising, internet, insurance, equipment, repair, postage, and all the other miscellaneous costs of running a business. The only expenses that should be excluded are those directly billable to the client and for which the photographer will be reimbursed. These would include costs such as aircraft and pilot time, film and processing, and other billable expenses. Add personal expenses like a livable wage, healthcare, and retirement to the total as well.

Now, divide the business overhead by the number of days available for photography. The result is the minimum amount of money the studio must generate each photography day to stay in business.

"Developing a fee structure for your services can be a complex task."

◾ Estimating Airtime and Expenses

Estimating the amount of airtime required to complete an assignment is not an easy task. Prior experience flying in the area can help, but many times delays are caused by unpredictable events. Delays in takeoff, landing, and during flight can quickly consume estimated airtime. Trying to predict flight times outside your general area of operation can often be pure speculation. Nothing is more frustrating than being put on hold by air traffic control and forced to fly in a lazy circle while costly airtime ticks by. Unfortunately, these expensive delays cannot always be predicted or avoided.

The only solution is to increase the estimated time and expense required to complete the assignment in order to cover any unexpected delays. But be careful not to increase your estimate too much (especially in a bidding situation), or you may lose the job to a competitor.

The best approach is to be honest with your client. If you suspect there may be difficulties, be sure to convey your concerns beforehand. Let the client know that you are giving an estimate, not a firm fixed price, of what it will cost to complete the assignment based upon your professional experience. All estimates should state "All prices may vary + or - 10%" as well as "Quoted prices are for estimation only. Actual billings will reflect real, not estimated, prices" or words to a similar effect.

Always ask for an advance deposit at least equal to the amount of estimated expenses before work begins. If this is a new client, you may want to request payment in full. The high cost of airtime can quickly slow your business cash flow to a crawl, siphoning off money that could be used more effectively elsewhere.

Deciding if weather conditions are acceptable, or if the flight should be canceled and flown later, is another potential expense that is difficult to estimate in advance. Try to make the cost of a typical amount of weather delay built into your quoted fees. Always ask the client about deadline pressure and, when possible, have them make the decision of whether to fly and risk the cost of a reshoot or to reschedule for another day.

◾ Maximize Time and Profit

All businesses benefit from time management techniques, which help to maximize the return on time spent conducting business. However, in aerial photography, maximizing the time aloft can be especially rewarding. The time spent driving to the airport, pre-flighting the aircraft, and the take-off and landing can often take longer than the actual flight itself. By photographing as many locations as possible during one flight, the time required and the

> "... many times delays are caused by unpredictable events."

When photographing cityscapes, try to place an
identifying landmark in the photograph to estab-
lish a sense of place (above, the Hollywood sign
in Los Angeles and right, the Golden Gate Bridge
in San Francisco).

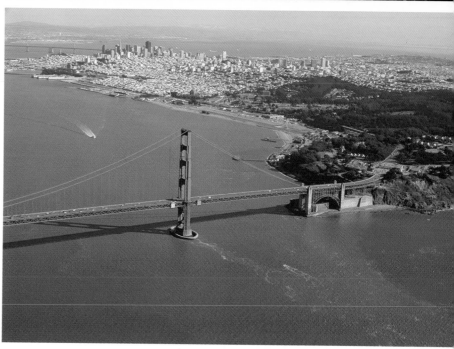

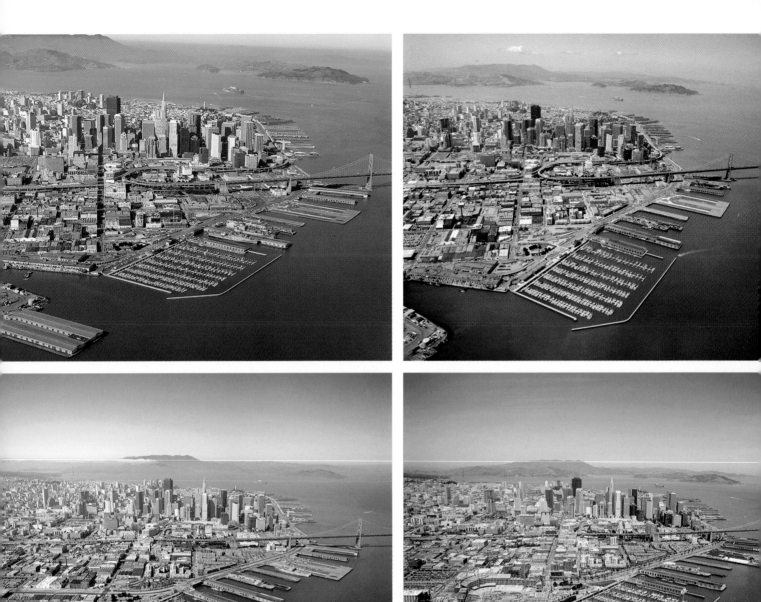

Photographs of areas under reconstruction can be marketed to a variety of firms and provide multiple assignments over the years (above, the San Francisco Sotuh Beach Redevelopment).

Many designs of nature, such as the patterns of salt evap-
oration ponds, are not visible from the ground.

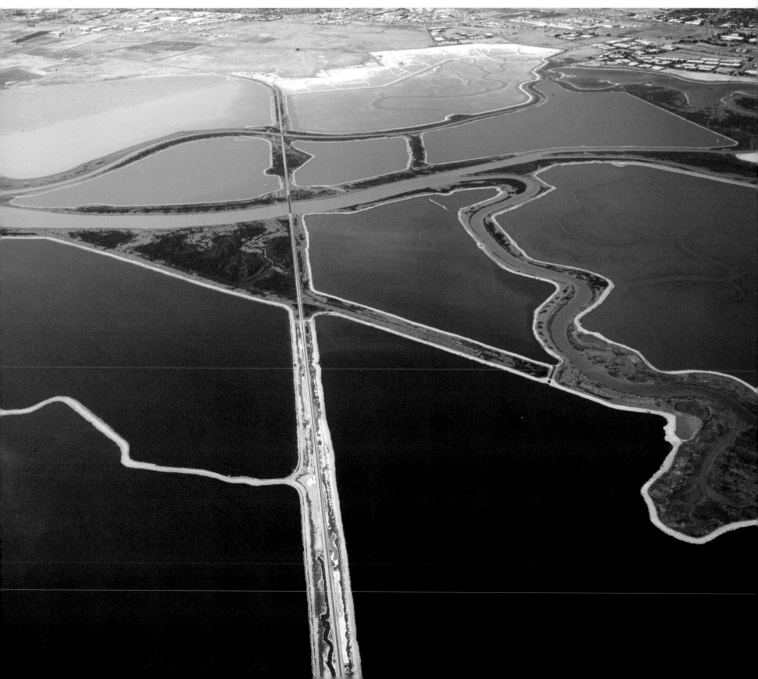

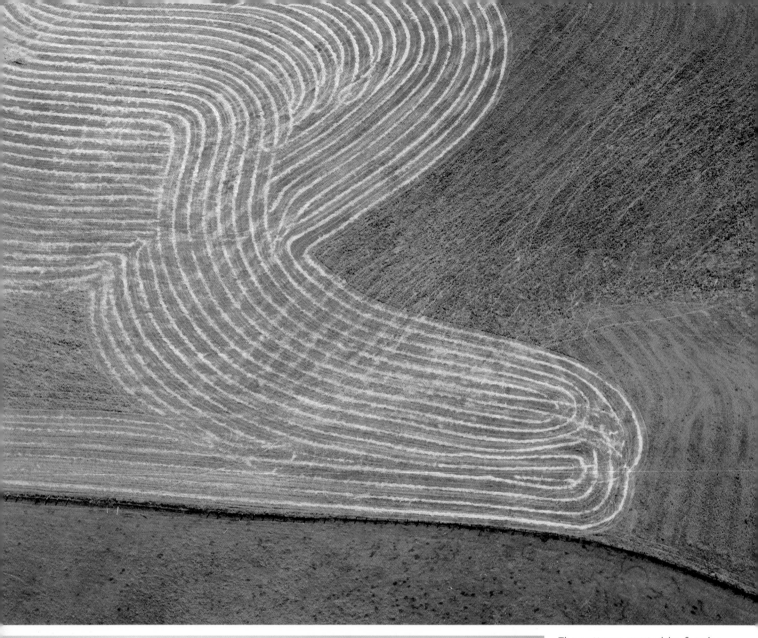

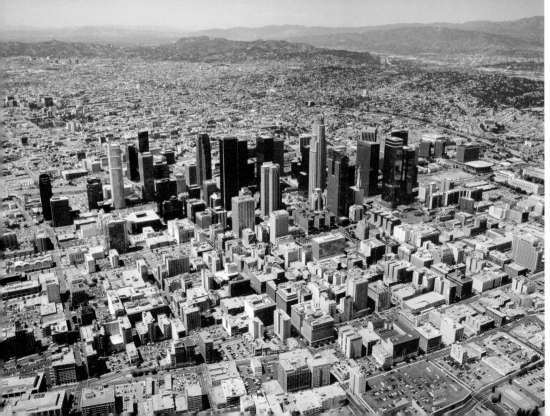

The patterns created by farming (above) are a frequent subject of aerial photographers.

Some of the best days for aerial photography (left) occur after the passing of a low pressure front which stirs up the atmosphere. On days such as these, visibility can exceed fifty miles.

expense of the airtime can be spread out between multiple clients, thereby lowering the cost per location.

Sometimes assignments will stack up due to a lack of proper weather conditions for photography. Another way to maximize the amount of profit you bring in per flight hour is by keeping a file of client needs and requests and then pooling assignments. Direct mail advertising also works well. A pre-planned schedule of areas where you will be flying can be used as a marketing tool to help pre-sell flights.

☐ Stock Photography

Stock photography also represents a large market for aerial photography. Images from previous assignments, those shot while traveling to and from locations, or photos taken on special stock

By using a stock agent to reach a world-wide market and increase sales, this image has generated over $7000.00 in revenue to date.

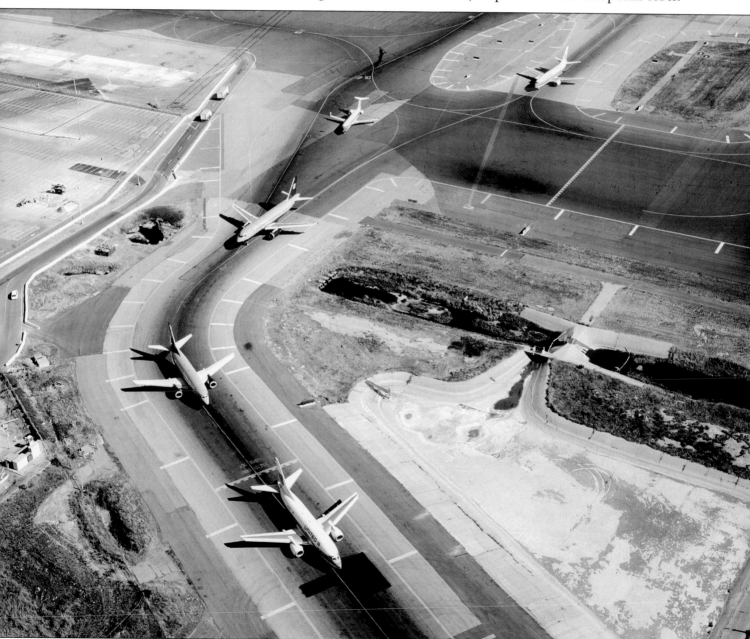

photography flights can all be used to this end. The ability to sell (and resell) an image helps spread the cost of doing business among many clients and allows a photograph to continue to produce revenue for a number of years.

Images can be sold directly by the photographer or through the services of a stock agent. Local markets, such as real estate and construction, are best served directly by the photographer, while a stock agent will allow you to widen your market into areas heretofore excluded from your client list. Before signing with a stock agent, carefully go over the contract. Pay particular attention to the length and type of representation, the amount of commission the agent receives, the length of time from the sale until the agent pays the studio, and any additional costs that will be incurred by the photographer, such as catalogues and duplication charges.

Stock photography rates are based upon how and where the image will be used. Rates for a national ad campaign will be high-

"Local markets, such as real estate and construction, are best served directly..."

When shooting for the cover of a publication, always leave room for the type to be inserted.

San Francisco Examiner

IMAGE

MARCH 28, 1993

PEOPLE'S PARK

What's next for the Presidio?

By Gerald D. Adams

Going Full Throttle
By Douglas Cruickshank

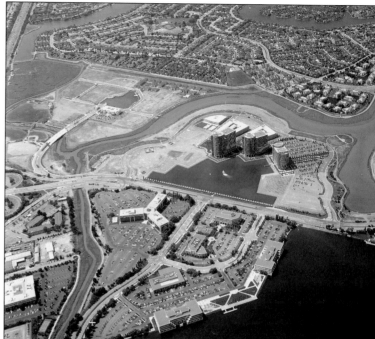
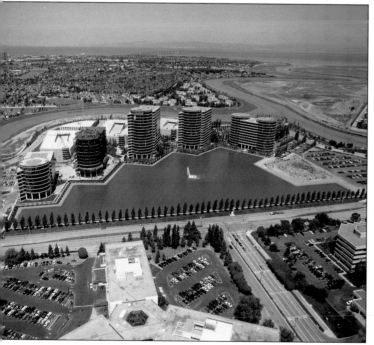
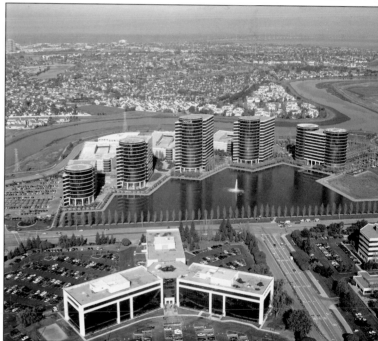

Large construction projects can take years to complete, providing a source of steady income.

er than for an insert in a small local paper. A typical sale might read "One Time Only, Non Exclusive North American Usage, inside 1/2 page, full color brochure with a press run below 5,000." Because the rates can be fairly complicated, a pricing guide such as *Negotiating Stock Photo Prices* by Jim Picerell is recommended. Many books on the business of stock photography include detailed information on entering this market.

☐ Additional Markets

An additional advantage to aerial photography is the number of sub-markets where a photograph can be sold. Images with poten-

tial for multiple sales include construction, real estate, hotels, ships, shopping malls, downtown urban areas, and vacation resorts.

For example, a client may commission a series of photographs to be taken of a hotel under construction for use in financial packages and construction progress reports, with the final assignment being a portrait of the finished hotel. Photographs of the hotel under construction would be of interest to every firm involved in the project. These would include the architects, engineers, contractors, landscapers, roofers and even the painters. Photographs of the finished hotel would add the hotel owners and guests to the list. These are all potentially high-profit sales because the expense of taking the photograph has already been paid.

However, care should taken not to sell the image when it could possibly conflict with the original client's uses. Usage terms,

> "... a client may commission a series of photographs..."

Today, this composite of an architectural model and the proposed building site can easily be created with a computer.

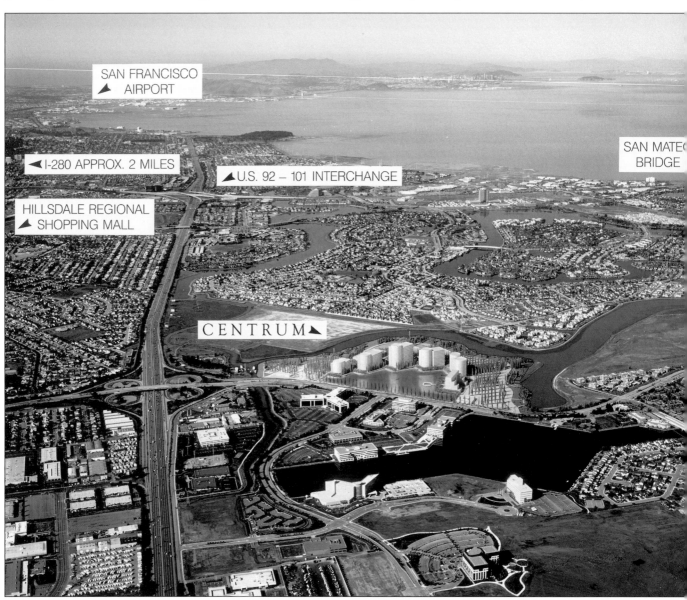

SAN FRANCISCO ▲ AIRPORT

SAN MATE(BRIDGE

◄ I-280 APPROX. 2 MILES

▲ U.S. 92 – 101 INTERCHANGE

HILLSDALE REGIONAL ▲ SHOPPING MALL

C E N T R U M ▲

including both the type and the length of the license, should be noted on the invoice to avoid any confusion.

☐ Records

A detailed set of records should be maintained for both business accounting and for assignments. If you are a pilot, you already keep a flight log, but a film log detailing the camera, lens, film, and altitude, plus an assignment outline of the project, should be included as well. These can be extremely helpful later when a client asks to have a particular photograph updated or recreated. These and other sample forms are included in Appendix C.

Each project should be assigned its own unique serial number, which should be attached to all negatives and prints for later identification. A simple numbering system would consist of a job number and a frame number; for example, ID#1025-07 would denote 1025 as the job and 07 as the number of the individual image. It also helps to designate a specific job number strictly for stock images so that they can be easily added to your files as they grow. Be sure to include your studio name and phone number as well as your copyright notice. The serial number will make ordering reprints easier for clients, and the studio tag will help to prevent unauthorized usage.

Always remember that the business of aerial photography, like any other type of studio photography, is just that: business. As such, it requires an understanding of basic business principles and techniques. Books and classes on general business subjects such as cash management, marketing, and promotion will help your business thrive and grow.

"Each project should be assigned its own unique serial number..."

CONCLUSIONS **11**

Hopefully, the knowledge and techniques acquired through this book, coupled with your own observations and experiences, will cover most situations. However, the true key to successful aerial photography is continued education and growth. Take the time to talk with your pilot and to network with your peers. You will gain not only valuable insight and perspective from the experiences of others, but that acquired knowledge will validate your own experiences as well.

Perhaps most important is to always try to enjoy your time aloft. When working professionally, it's easy to become focused on the objective of the flight to the exclusion of everything else. Client pressures and deadline demands can dull anyone's day. However, if you are like most people, it was the opportunity to fly that first attracted you to aerial photography. I know of few professions today that combine such a wonderful commute with so enjoyable a workday.

"... always try to enjoy your time aloft."

UNDERSTANDING AN A.T.I.S. REPORT

"The report is updated hourly..."

The Automated Terminal Information System, or ATIS, are reports issued by the tower on current airport conditions. Available over the phone and on the internet, these reports are not forecasts. Rather, they are a rundown of current weather conditions and information on airport operations. The report is updated hourly or whenever there is a significant change. Much of the report (such as runways in use) is only of interest to the pilot, but valuable information on cloud cover, wind, visibility, and dewpoint is also included and can give you a much better idea of conditions at the airfield.

Try to listen to at least three updates to obtain a feel for current weather conditions and to gauge how rapidly they are changing. Some of the measurements are simply someone in the tower looking out the window and reporting on what they see, so a certain amount of interpretation is required. However, once the terms used are understood, the report becomes a great source of weather information. Inquire at the airport tower for the telephone number for local automated service.

▢ Commonly Used Terms

• Zulu Time
Greenwich Mean Time, also referred to as UTC, is the time zone used as a reference point to provide a universal clock. Add or subtract the correct number of zones from Zulu to establish the local time.

• Cloud Cover
Although the category of cloud is generally not noted, the altitude and the amount of coverage are. Common cloud cover abbreviations include:

Clear	=	less than 10% of sky covered
Scattered	=	10% to 50% of sky covered
Broken	=	60% to 90% covered
Overcast	=	more than 90% covered

• Wind

Although of more concern to the pilot, the wind speed can help to predict if air quality will improve. A windy day can make for a bumpy ride, but the wind will help to clear haze from the skies and offer the clearest views. The wind speed is often expressed in knots.

• Visibility

The estimated visibility in miles, as measured from the airport tower. This number is a good indication of the amount of haze present in the atmosphere. A minimum visibility of ten miles is recommended for most aerial photography.

• Dewpoint

The temperature at which water will condense in the atmosphere; also, an an indication of the temperature at which fog will begin to form.

CAMERA VIEWPOINTS FROM A CESSNA

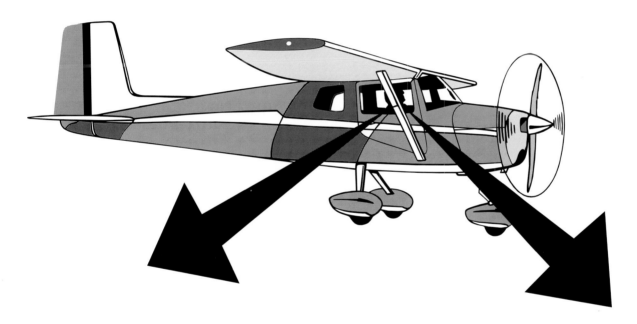

The best sight lines from a Cessna 172 are from the rear quadrant between the strut and tail. It is possible to shoot through the front quadrant, but care must be taken not to include the propeller in the photograph.

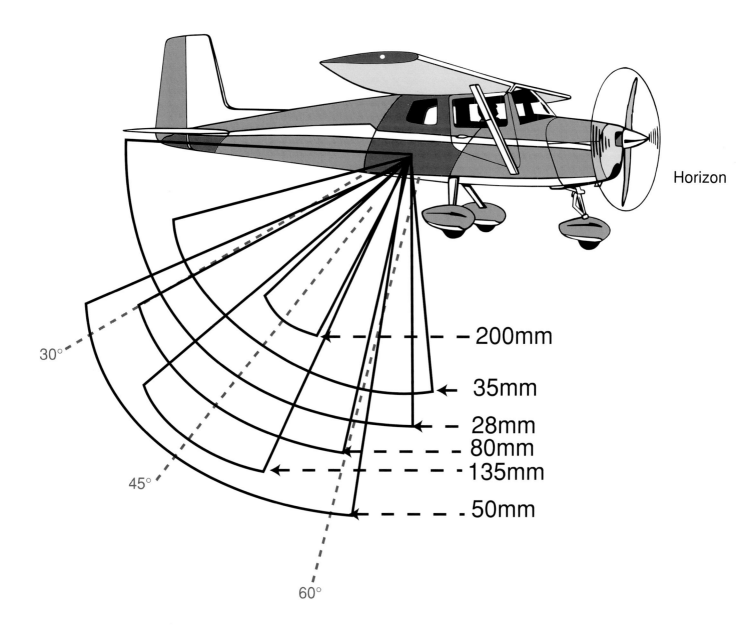

Horizon

200mm

35mm

28mm
80mm
135mm

50mm

30°

45°

60°

The approximate angles of view for commonly used 35mm camera lenses. Double the focal lengths listed for coverage using medium format cameras.

Authors Note:

The publisher inserted the wrong illustration on page 90. The correct illustration appears below.

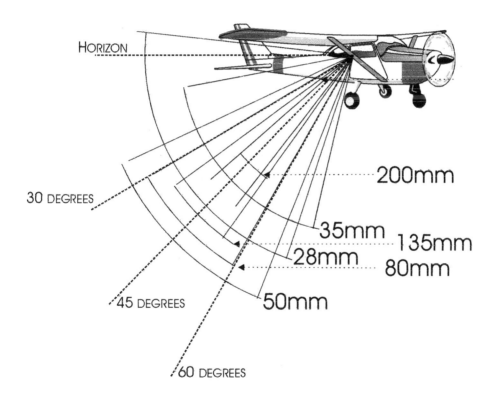

The approximate angles of view for commonly used 35mm camera lenses. Double the focal lengths listed for coverage using medium format cameras.

SAMPLE BUSINESS FORMS

"Be sure to include your terms and conditions..."

The following are three forms useful in the day to day operation of an aerial photography business. Two, the architectural assignment order form and the film log, are intended for internal use only. The job estimate should have your terms and conditions printed on the back of the customer's copy.

Be sure to include your terms and conditions on the back of all estimates, invoices, and stock submission forms. The American Society of Media Photographers, or A.S.M.P, is a good source for additional forms and information on professional photography business practices in general.

Assignment Order Form

JOB#	**DUE DATE:**
DATE:	**CLIENT P.O.#:**
CLIENT NAME:	**PHONE#:**
ORDERED BY:	**FAX#:**
Shipping Address:	Billing Address:

PHOTO DESCRIPTION: **LOCATION:**

❏ UNDEVELOPED ❏ UNDER CONSTRUCTION ❏ COMMERCIAL BLDG. ❏ RESIDENTIAL

Size of Area to be Photographed: Include/Exclude:

Building Orientation: Identifying Marks:

Building Height: Square Feet:

Angle of View: Best Time of Day:

 ❏ Vertical ❏ Oblique ❏ Display

Intended Usage:

FINAL FORM:

Print: Transparency:

Size: Send Original: ❏ Yes ❏ No

of Copies Proof: ❏ Yes ❏ No

Print Finish:

Special Needs or Requirements:

Job Estimate/Expenses

JOB#

DATE:

CLIENT NAME:

ORDERED BY:

Shipping Address:

DUE DATE:

CLIENT P.O.#:

PHONE#:

FAX#:

Billing Address:

PHOTO DESCRIPTION:

LOCATION:

Special Needs or Requirements:

Estimate/Expenses

Photography Fees:

Aircraft Rental:

Assistant:

Film & Processing:

Equipment Rental:

Travel Expenses:

Misc. Expenses:

TERMS: **Prices may vary + or -10%**
50% deposit required
Balance due upon completion

TOTAL: **(+TAX)**

Estimate is valid for 30 days from the date of issue. Final billing will reflect actual, not estimated expenses, plus applicable taxes. Fees and expenses quoted in this estimate are the original layout and job description only, and for the uses specified. Rights licensed only upon full payment and subject to the terms and conditions on reverse.

Film Log

JOB#				DATE:			
AIRCRAFT:				TIME OF DAY:			
PILOT:				WEATHER CONDITIONS:			

Frame#	Camera	Lens	Filter	Film	Exposure	Dev.	Altitude	View

APPENDIX D

ADDITIONAL RESOURCES

◼ Bibliography

American Society of Media Photographers
ASMP Professional Business Practices in Photography
ASMP, Fifth Edition, 1997

Brock, G.C.
Physical Aspects of Aerial Photography
Dover Publications, 1967

Kodak Publication M-5
Photography From Lightplanes and Helicopters
Eastman Kodak Company, 1985

Newhall, Beaumont
Airborne Camera: The world from the air and outer space
Hastings House Publishers, 1969

Pickerell, Jim and Cheryl
Negotiating Stock Photo Prices
Taking Stock, Updated 1997

◼ Recommended Reading

Dreikausen, Margret
*Aerial Perception: The Earth as Seen from Aircraft and Spacecraft
and It's Influence on Contemporary Art*
Associated University Presses, 1985

Gerster, Georg
Below From Above
Abbeville Press, 1986

◻ Professional Organizations

• **The American Society of Media Photographers (ASMP)**
> 14 Washington Road
> Suite 502
> Princeton Junction, NJ 08550
> (609) 799-8300
> http://www.asmp.org

• **The Professional Photographers of America (PPA)**
> 229 Peachtree St., NE, #2200
> Atlanta, GA 30303-2206
> (404) 522-8600
> membership@ppa-world.org
> http://www.ppa-world.org/

• **The Professional Aerial Photographers Association (PAPA)**
> Ted Campbell
> 2725 17th Street
> Columbus, IN 47201
> (812) 372-9971
> papa@hsonline.net
> http://www.positiveimage.com/papa/

• **The Picture Agency Council of America (PACA)**
> Stock Photography Information
> P.O. Box 308
> Northfield, Minnesota 55057
> (507) 645-7066
> http://www.pacaoffice.org/

◻ Internet Forums

• **Aerialpro The Professional Aerial Photography Forum**
> Aerialpro@aerialimages.com
> http://www.aerialimages.com/links/aerialpro/aerialpro.html

• **The Stock Photo Network**
> http://www.stockphoto.net/

◻ Government Agencies

• **Federal Aviation Administration (FAA)**
> 800 Independence Avenue, S.W.
> Washington D.C. 20591
> http://www.faa.gov/

◻ Aviation Charts

• **Aircraft Owners and Pilots Association (AOPA)**

 421 Aviation Way

 Fredrick, MD 21701

 (301) 695-2000

 http://www.aopa.org/

• **National Oceanic and Atmospheric Administration (NOAA)**

 Distribution Branch

 N-ACC3

 61 Lafayette Avenue

 Riverdale, MD 20737

 (800) 638-8972

◻ Equipment and Supplies

• **Eastman Kodak**

 Kodak Information Center

 (800) 242-2424 x19

 http://www.kodak.com/go/professional

• **GPS Receivers**

 Garmin

 1200 East 151st Street

 Olathe, Kansas 660062

 (913) 397-8200

 http://www.garmin.com/

 Magellan

 960 Overland Court

 San Dimas, CA 91773

 (909) 394-5000

• **Ken-Lab Gyrostabilizers**

 Kenyon Laboratories LLC

 29 Plains Road

 Essex, CT 06426

 (800) 253-4681

 http://www.ken-lab.com/

• **Pentax Corp.**

 35 Inverness Drive East

 Englewood, CO 81055

 (800) 877-0155

 http://www.pentax.com

- **Tamrac, Inc**
 9240 Jordan Ave.
 Chatsworth, CA 91311
 (800) 662-0717
 http://www.tamrac.com

☐ Solar Tables

 Astronomical Applications Department
 U.S. Naval Observatory
 3450 Massachusetts Avenue NW
 Washington, DC 20392-5420
 (202) 762-1617
 http://aa.usno.navy.mil/AA/

GLOSSARY

• Average Scene Brightness

A reflectance rate of 18% is considered to be the average scene brightness. Most meters are set to provide the correct exposure for a subject of average brightness and can be fooled by subjects with higher or lower values.

• Airspeed

The speed at which the aircraft is moving through the air. This can differ from ground speed due to wind conditions aloft.

• Altimeter

A device for measuring the height of the aircraft. Some readouts are expressed as Above Ground Level (or AGL), however, the actual altitude, measured as the distance above sea level, is the height of the ground and the aircraft combined.

• Auto Focus Systems

A common feature on many 35mm cameras AF systems use a beam of light to gauge the distance to the subject and then set the focus of the camera automatically.

• Bracketing Exposure

Making exposures over and under the recommended camera settings. A typical "bracket" would be one stop over and one stop under taken in 1/2 stop increments.

• "Class B" Airspace

An area where flight is restricted or limited to a particular altitude or flight path. Sometimes referred to as Traffic Control Areas, or TCA's.

• Daylight Savings Time

One hour ahead of standard time. From the first Sunday in April

until the last Sunday in October, most of the United States and Canada switch to daylight savings time. A few states, such as Hawaii, do not switch but remain on standard time throughout the year.

• Depth of Field
The area of focus for a given f-stop and focusing distance. The higher the f-stop, the larger the depth of field. DOF is usually not a concern in aerial photography.

• Exposure Latitude
The amounts by which a film can be over or underexposed and still produce acceptable results. Different from film to film, the EL ranges from a high of $1^{1}/_{2}$ to 2 stops for some negative emulsions to as little as $1/3$ of a stop for certain transparency films.

• Filter Factor
The amount by which exposure must be increased to compensate for the absorption of light by a filter.

• Fixed Wing Aircraft
Aircraft with the wings attached to the fuselage (as opposed to a rotorcraft, such as a helicopter).

• Focal Length
The length from the optical center of the lens to the point at which it forms a sharp focus when set at infinity. The number is usually expressed in millimeters, such as a 50mm lens.

• Greenwich Mean Time
The time zone based upon the meridian of Greenwich and used as the prime basis for standard time through the world. Sometimes called UT for universal time.

• Ground Speed
The speed at which the aircraft is moving relative to a position on the ground. This may differ from the airspeed due to weather conditions aloft.

• Global Positioning System
The GPS is a navigation system using satellite transmissions to locate one's position on the planet to within a few feet. Originally developed for use by the military, small handheld units are now commercially available.

• High Wing Aircraft
An airplane with the wings attached to the top of the fuselage allowing for better visibility below.

- **Hobbs Meter**

Used to track the number of hours an aircraft has operated, the Hobbs meter functions somewhat like the odometer in an automobile. The meter begins running when the engine is turned on and continues to run until the engine is shut down. Most rental aircraft are billed based on the Hobbs meter.

- **Infinity Setting**

The setting on a lens where, from that point on, everything will be in focus. Usually marked on the lens with an infinity symbol. Although the focus ring on most lenses cannot be rotated beyond the infinity setting, it helps to test your own.

- **Knots**

A measurement of distance expressed in nautical miles per hour. Roughly equal to 1.85 Kilometers, or 1.15 statute miles per hour.

- **Low Wing Aircraft**

An airplane with the wings attached to the bottom of the fuselage. Because the wings obscure the view below, low wing aircraft are not suitable for most types of aerial photography.

- **Normal Lens**

A lens with a focal length which provides the same angle of view as the human eye. The normal (or standard) lens varies according to the film size. A 50mm lens is considered "normal" for a 35mm format, a 100mm lens for a 6x7.

- **Push Process**

Changing the development cycle of a film to cause an increase in film speed and/or to control contrast.

- **Rotorcraft**

Another name for a helicopter.

- **Solar Table**

A table showing the position of the sun for a given time and day of the year.

- **Snip Test**

A snip, or clip test, processes the first (or the last) few frames on a roll to check development times.

- **Spot Meter**

A meter with a limited angle of view, allowing for greater control over the area to be metered.

- **Stall Speed**

The speed at which the airflow under the wings no longer pro-

vides lift to the aircraft. Each aircraft has is own stall speed.

• Standard Time
A time zone where everyone shares the same standard time, such as Pacific Standard Time (or PST).

• Teleconverter
Mounted between the camera and the lens a teleconverter lengthens the focal length of the lens. Some designs work better than others do, so check for any degradation or image softness before you purchase one.

• Telephoto Lens
A lens with a focal length longer than standard for the film format. Telephotos with a focal length longer than 2x to 3x normal can be difficult to use in the air.

• Temperature Inversion
A condition where the air aloft is warmer than the air at ground level.

• Thermals
A rising current of warm air often encountered late in the day.

• Weather Front
The boundary between two dissimilar air masses. The resulting winds associated with a passing front can help to clear the atmosphere and improve air quality.

• Wet/Dry Rental
The hourly rental charge for a "wet" aircraft includes the fuel consumed. A "Dry" aircraft will add the fuel costs as a separate expense.

• Wet Plate Process
The collodion, or wet plate process, required the photographer to coat a glass plate with the collodion mixture immediately before exposure. Then, in total darkness, the plates where developed in a silver nitrate solution. Because the process required that all steps, from sensitizing to exposure to development, occur within 20minutes a nearby darkroom was required.

• Wide Angle Lens
A lens with a focal length shorter than standard for the film format. A 28mm lens on a 35mm camera is the widest lens that can easily be used in a Cessna 172.

• Zulu Time
Universal or Greenwich Mean Time.

INDEX

Other Books from
Amherst Media, Inc.

Basic 35mm Photo Guide

Craig Alesse

Great for beginning photographers! Designed to teach 35mm basics step-by-step — completely illustrated. Features the latest cameras. Includes: 35mm automatic, semi-automatic cameras, camera handling, *f*-stops, shutter speeds, and more! $12.95 list, 9x8, 112p, 178 photos, order no. 1051.

Build Your Own Home Darkroom

Lista Duren & Will McDonald

This classic book teaches you how to build a high quality, inexpensive darkroom in your basement, spare room, or almost anywhere. Includes valuable information on: darkroom design, woodworking, tools, and more! $17.95 list, 8½x11, 160p, order no. 1092.

Into Your Darkroom Step-by-Step

Dennis P. Curtin

This is the ideal beginning darkroom guide. Easy to follow and fully illustrated each step of the way. Includes information on: the equipment you'll need, set-up, making proof sheets and much more! $17.95 list, 8½x11, 90p, hundreds of photos, order no. 1093.

Wedding Photographer's Handbook

Robert and Sheila Hurth

A complete step-by-step guide to succeeding in the world of wedding photography. Packed with shooting tips, equipment lists, must-get photo lists, business strategies, and much more! $24.95 list, 8½x11, 176p, index, b&w and color photos, diagrams, order no. 1485.

Lighting for People Photography, 2nd ed.

Stephen Crain

The up-to-date guide to lighting. Includes: set-ups, equipment information, strobe and natural lighting, and much more! Features diagrams, illustrations, and exercises for practicing the techniques discussed in each chapter. $29.95 list, 8½x11, 120p, b&w and color photos, glossary, index, order no. 1296.

Camera Maintenance & Repair Book 1

Thomas Tomosy

A step-by-step, illustrated guide by a master camera repair technician. Includes: testing camera functions, general maintenance, basic tools needed and where to get them, basic repairs for accessories, camera electronics, plus "quick tips" for maintenance and more! $29.95 list, 8½x11, 176p, order no. 1158.

Camera Maintenance & Repair Book 2

Thomas Tomosy

Build on the basics covered Book 1, with advanced techniques. Includes: mechanical and electronic SLRs, zoom lenses, medium format cameras, and more. Features models not included in the Book 1. $29.95 list, 8½x11, 176p, 150+ photos, charts, tables, appendices, index, glossary, order no. 1558.

Restoring the Great Collectible Cameras (1945-70)

Thomas Tomosy

More step-by-step instruction on how to repair collectible cameras. Covers postwar models (1945-70). Hundreds of illustrations show disassembly and repair. $29.95 list, 8½x11, 128p, 200+ photos, index, order no. 1560.

Big Bucks Selling Your Photography

Cliff Hollenbeck

A complete photo business package. Includes secrets for starting up, getting paid the right price, and creating successful portfolios! Features setting financial, marketing and creative goals. Organize your business planning, bookkeeping, and taxes. $15.95 list, 6x9, 336p, order no. 1177.

Outdoor and Location Portrait Photography

Jeff Smith

Learn how to work with natural light, select locations, and make clients look their best. Step-by-step discussions and helpful illustrations teach you the techniques you need to shoot outdoor portraits like a pro! $29.95 list, 8½x11, 128p, b&w and color photos, index, order no. 1632.

Make Money with Your Camera

David Arndt

Learn everything you need to know in order to make money in photography! David Arndt shows how to take highly marketable pictures, then promote, price and sell them. Includes all major fields of photography. $29.95 list, 8½x11, 120p, 100 b&w photos, index, order no. 1639.

Leica Camera Repair Handbook

Thomas Tomosy

A detailed technical manual for repairing Leica cameras. Each model is discussed individually with step-by-step instructions. Exhaustive photographic illustration ensures that every step of the process is easy to follow. $39.95 list, 8½x11, 128p, 130 b&w photos, appendix, order no. 1641.

Guide to International Photographic Competitions

Dr. Charles Benton

Remove the mystery from international competitions with all the information you need to select competitions, enter your work, and use your results for continued improvement and further success! $29.95 list, 8½x11, 120p, b&w photos, index, appendices, order no. 1642.

Freelance Photographer's Handbook

Cliff & Nancy Hollenbeck

Whether you want to be a freelance photographer or need tips to improve your current freelance business, this volume is packed with ideas for creating and maintaining a successful freelance business. $29.95 list, 8½x11, 107p, 100 b&w and color photos, index, glossary, order no. 1633.

Infrared Landscape Photography

Todd Damiano

Landscapes in infrared can become breathtaking and ghostly images. The author analyzes over fifty of his most compelling photographs to teach you the techniques you need to capture landscapes with infrared. $29.95 list, 8½x11, 120p, b&w photos, index, order no. 1636.

Wedding Photography: Creative Techniques for Lighting and Posing

Rick Ferro

Creative techniques for lighting and posing wedding portraits that will set your work apart from the competition. Covers every phase of wedding photography. $29.95 list, 8½x11, 128p, b&w and color photos, index, order no. 1649.

Professional Secrets of Advertising Photography

Paul Markow

No-nonsense information for those interested in the business of advertising photography. Includes: how to catch the attention of art directors, make the best bid, and produce the high-quality images your clients demand. $29.95 list, 8½x11, 128p, 80 photos, index, order no. 1638.

Lighting Techniques for Photographers

Norm Kerr

This book teaches you to predict the effects of light in the final image. It covers the interplay of light qualities, as well as color compensation and manipulation of light and shadow. $29.95 list, 8½x11, 120p, 150+ color and b&w photos, index, order no. 1564.

Infrared Photography Handbook

Laurie White

Covers black and white infrared photography: focus, lenses, film loading, film speed rating, batch testing, paper stocks, and filters. Black & white photos illustrate how IR film reacts. $29.95 list, 8½x11, 104p, 50 b&w photos, charts & diagrams, order no. 1419.

How to Shoot and Sell Sports Photography

David Arndt

A step-by-step guide for amateur photographers, photojournalism students and journalists seeking to develop the skills and knowledge necessary for success in the demanding field of sports photography. $29.95 list, 8½x11, 120p, 111 photos, index, order no. 1631.

How to Operate a Successful Photo Portrait Studio

John Giolas

Combines photographic techniques with practical business information to create a complete guide book for anyone interested in developing a portrait photography business (or improving an existing business). $29.95 list, 8½x11, 120p, 120 photos, index, order no. 1579.

Fashion Model Photography

Billy Pegram

For the photographer interested in shooting commercial model assignments, or working with models to create portfolios. Includes techniques for dramatic composition, posing, selection of clothing, and more! $29.95 list, 8½x11, 120p, 58 photos, index, order no. 1640.

Computer Photography Handbook

Rob Sheppard

Learn to make the most of your photographs using computer technology! From creating images with digital cameras, to scanning prints and negatives, to manipulating images, you'll learn all the basics of digital imaging. $29.95 list, 8½x11, 128p, 150+ photos, index, order no. 1560.

Achieving the Ultimate Image

Ernst Wildi

Ernst Wildi teaches the techniques required to take world class, technically flawless photos. Features: exposure, metering, the Zone System, composition, evaluating an image, and more! $29.95 list, 8½x11, 128p, 120 b&w and color photos, index, order no. 1628.

Black & White Portrait Photography

Helen Boursier

Make money with b&w portrait photography. Learn from top b&w shooters! Studio and location techniques, with tips on preparing your subjects, selecting settings and wardrobe, lab techniques, and more! $29.95 list, 8½x11, 128p, 130+ photos, index, order no. 1626

The Beginner's Guide to Pinhole Photography

Jim Shull

Take pictures with a camera you make from stuff you have around the house. Develop and print the results at home! Pinhole photography is fun, inexpensive, educational and challenging. $17.95 list, 8½x11, 80p, 55 photos, charts & diagrams, order no. 1578.

Stock Photography

Ulrike Welsh

This book provides an inside look at the business of stock photography. Explore photographic techniques and business methods that will lead to success shooting stock photos — creating both excellent images and business opportunities. $29.95 list, 8½x11, 120p, 58 photos, index, order no. 1634.

Profitable Portrait Photography

Roger Berg

A step-by-step guide to making money in portrait photography. Combines information on portrait photography with detailed business plans to form a comprehensive manual for starting or improving your business. $29.95 list, 8½x11, 104p, 100 photos, index, order no. 1570

Professional Secrets for Photographing Children

Douglas Allen Box

Covers every aspect of photographing children on location and in the studio. Prepare children and parents for the shoot, select the right clothes capture a child's personality, and shoot story book themes. $29.95 list, 8½x11, 128p, 74 photos, index, order no. 1635.

Restoring Classic & Collectible Cameras
(Pre-1945)

Thomas Tomosy

Step-by-step instructions show how to restore a classic or vintage camera. Repair mechanical and cosmetic elements to restore your valuable collectibles. $34.95 list, 8½x11, 128p, b&w photos and illus., glossary, index, order no. 1613.

Handcoloring Photographs Step-by-Step

Sandra Laird & Carey Chambers

Learn to handcolor photographs with the new standard in handcoloring reference books. Covers a variety of coloring media and techniques with plenty of colorful photographic examples. $29.95 list, 8½x11, 112p, 100+ color and b&w photos, order no. 1543.

Special Effects Photography Handbook

Elinor Stecker Orel

Create magic on film with special effects! Little or no additional equipment required, use things you probably have around the house. Step-by-step instructions guide you through each effect. $29.95 list, 8½x11, 112p, 80+ color and b&w photos, index, glossary, order no. 1614.

McBroom's Camera Bluebook, 6th ed.

Mike McBroom

Comprehensive and fully illustrated, with price information on: 35mm, digital, APS, underwater, medium & large format cameras, exposure meters, strobes and accessories. Pricing info based on equipment condition. A must for any camera buyer, dealer, or collector! $29.95 list, 8½x11, 336p, 275+ photos, order no. 1553.

Fine Art Portrait Photography

Oscar Lozoya

The author examines a selection of his best photographs, and provides detailed technical information about how he created each. Lighting diagrams accompany each photograph. $29.95 list, 8½x11, 128p, 58 photos, index, order no. 1630.

Family Portrait Photography

Helen Boursier

Learn from professionals how to operate a successful portrait studio. Includes: marketing family portraits, advertising, working with clients, posing, lighting, and selection of equipment. Includes images from a variety of top portrait shooters. $29.95 list, 8½x11, 120p, 123 photos, index, order no. 1629.

The Art of Infrared Photography, *4th Edition*

Joe Paduano

A practical guide to the art of infrared photography. Tells what to expect and how to control results. Includes: anticipating effects, color infrared, digital infrared, using filters, focusing, developing, printing, handcoloring, toning, and more! $29.95 list, 8½x11, 112p, order no. 1052

Camcorder Tricks and Special Effects, *revised*

Michael Stavros

Kids and adults can create home videos and mini-masterpieces that audiences will love! Use materials from around the house to simulate an inferno, make subjects transform, create exotic locations, and more. Works with any camcorder. $17.95 list, 8½x11, 80p, order no. 1482.

The Art of Portrait Photography

Michael Grecco

Michael Grecco reveals the secrets behind his dramatic portraits which have appeared in magazines such as *Rolling Stone* and *Entertainment Weekly*. Includes: lighting, posing, creative development, and more! $29.95 list, 8½x11, 128p, order no. 1651.

Essential Skills for Nature Photography

Cub Kahn

Learn all the skills you need to capture landscapes, animals, flowers and the entire natural world on film. Includes: selecting equipment, choosing locations, evaluating compositions, filters, and much more! $29.95 list, 8½x11, 128p, order no. 1652.

Photographer's Guide to Polaroid Transfer

Christopher Grey

Step-by-step instructions make it easy to master Polaroid transfer and emulsion lift-off techniques and add new dimensions to your photographic imaging. Fully illustrated every step of the way to ensure good results the very first time! $29.95 list, 8½x11, 128p, order no. 1653.

Black & White Landscape Photography

John Collett and David Collett

Master the art of b&w landscape photography. Includes: selecting equipment (cameras, lenses, filters, etc.) for landscape photography, shooting in the field, using the Zone System, and printing your images for professional results. $29.95 list, 8½x11, 128p, order no. 1654.

Wedding Photojournalism

Andy Marcus

Learn the art of creating dramatic unposed wedding portraits. Working through the wedding from start to finish you'll learn where to be, what to look for and how to capture it on film. A hot technique for contemporary wedding albums! $29.95 list, 8½x11, 128p, order no. 1656.

Studio Portrait Photography of Children and Babies

Marilyn Sholin

Learn to work with the youngest portrait clients to create images that will be treasured for years to come. Includes tips for working with kids at every developmental stage, from infant to pre-schooler. Features: lighting, posing and much more! $29.95 list, 8½x11, 128p, order no. 1657.

Professional Secrets of Wedding Photography

Douglas Allen Box

Over fifty top-quality portraits are individually analyzed to teach you the art of professional wedding portraiture. Lighting diagrams, posing information and technical specs are included for every image. $29.95 list, 8½x11, 128p, order no. 1658.

Photographer's Guide to Shooting Model & Actor Portfolios

CJ Elfont, Edna Elfont and Alan Lowy

Create outstanding images for actors and models looking for work in fashion, theater, television, or film. Includes the business, photographic and professional information you need to succeed! $29.95 list, 8½x11, 128p, order no. 1659.

Photo Retouching with Adobe® Photoshop®

Gwen Lute

Designed for photographers, this manual teaches every phase of the process, from scanning to final output. Learn to restore damaged photos, correct imperfections, create realistic composite images and correct for dazzling color. $29.95 list, 8½x11, 120p, order no. 1660.

Creative Lighting Techniques for Studio Photographers

Dave Montizambert

Master studio lighting and gain complete creative control over your images. Whether you are shooting portraits, cars, table-top or any other subject, Dave Montizambert teaches you the skills you need to confidently create with light. $29.95 list, 8½x11, 120p, order no. 1666.

Storytelling Wedding Photography

Barbara Box

Barbara and her husband shoot as a team at weddings. Here, she shows you how to create outstanding candids (which are her specialty), and combine them with formal portraits (her husband's specialty) to create a unique wedding album. $29.95 list, 8½x11, 128p, order no. 1667.

Fine Art Children's Photography

Doris Carol Doyle and Ian Doyle

Learn to create fine art portraits of children in black & white. Included is information on: posing, lighting for studio portraits, shooting on location, clothing selection, working with kids and parents, and much more! $29.95 list, 8½x11, 128p, order no. 1668.

Infrared Portrait Photography

Richard Beitzel

Discover the unique beauty of infrared portraits, and learn to create them yourself. Included is information on: shooting with infrared, selecting subjects and settings, filtration, lighting, and much more! $29.95 list, 8½x11, 128p, order no. 1669.

Black & White Photography for 35mm

Richard Mizdal

A guide to shooting and darkroom techniques! Perfect for beginning or intermediate photographers who wants to improve their skills. Features helpful illustrations and exercises to make every concept clear and easy to follow. $29.95 list, 8½x11, 128p, order no. 1670.

Professional Secrets of Nature Photography

Judy Holmes

Improve your nature photography with this must-have book. Covers every aspect of making top-quality images, from selecting the right equipment, to choosing the best subjects, to shooting techniques for professional results every time. $29.95 list, 8½x11, 120p, order no. 1682.

Macro and Close-up Photography Handbook

Stan Sholik

Learn to get close and capture breathtaking images of small subjects – flowers, stamps, jewelry, insects, etc. Designed with the 35mm shooter in mind, this is a comprehensive manual full of step-by-step techniques. $29.95 list, 8½x11, 120p, order no. 1686.

Photographing Children in Black & White

Helen T. Boursier

Learn the techniques professionals use to capture classic portraits of children (of all ages) in black & white. Discover posing, shooting, lighting and marketing techniques for black & white portraiture in the studio or on location. $29.95 list, 8½x11, 128p, order no. 1676.

Marketing and Selling Black & White Portrait Photography

Helen T. Boursier

A complete manual for adding b&w portraits to the products you offer clients (or offering exclusively b&w). Learn how to attract clients and deliver the portraits that will keep them coming back. $29.95 list, 8½x11, 128p, order no. 1677.

Outdoor and Survival Skills for Nature Photographers

Ralph LaPlant and Amy Sharpe

An essential guide for photographing outdoors. Learn how to have a safe and productive shoot – from selecting equipment, to finding subjects, to preventing (or dealing with) injury and accidents. $17.95 list, 8½x11, 80p, order no. 1678.

Art and Science of Butterfly Photography

William Folsom

Learn to understand and predict butterfly behavior (including feeding, mating and migrational patterns), when to photograph them and even how to lure butterflies. Then discover the photographic techniques for capturing breathtaking images of these colorful creatures. $29.95 list, 8½x11, 120p, order no. 1680.

Infrared Wedding Photography

Patrick Rice, Barbara Rice & Travis HIll

Step-by-step techniques for adding the dreamy look of black & white infrared to your wedding portraiture. Capture the fantasy of the wedding with unique ethereal portraits your clients will love! $29.95 list, 8½x11, 128p, order no. 1681.

Practical Manual of Captive Animal Photography

Michael Havelin

Learn the environmental and preservational advantages of photographing animals in captivity – as well as how to take dazzling, natural-looking photos of captive subjects (in zoos, preserves, aquariums, etc.). $29.95 list, 8½x11, 120p, order no. 1683.

Composition Techniques from a Master Photographer

Ernst Wildi

In photography, composition can make the difference between dull and dazzling. Master photographer Ernst Wildi teaches you his techniques for evaluating subjects and composing powerful images. $29.95 list, 8½x11, 128p, order no. 1685.

Innovative Techniques for Wedding Photographers

David Arndt

Spice up your wedding photography (and attract new clients) with dozens of creative techniques from top-notch professional wedding photographers! $29.95 list, 8½x11, 120p, order no. 1684.

Dramatic Black & White Photography:
Shooting and Darkroom Techniques

J.D. Hayward

Create dramatic fine-art images and portraits with the master b&w techniques in this book. From outstanding lighting techniques to top-notch, creative darkroom work, this book takes b&w to the next level! $29.95 list, 8½x11, 128p, order no. 1687.

Photographing Your Artwork

Russell Hart

A step-by-step guide for taking high-quality slides of artwork for submission to galleries, magazines, grant committees, etc. Learn the best photographic techniques to make your artwork (be it 2D or 3D) look its very best! $29.95 list, 8½x11, 128p, order no. 1688.

Studio Portrait Photography in Black & White

David Derex

From concept to presentation, you'll learn how to select clothes, create beautiful lighting, prop and pose top-quality black & white portraits in the studio. $29.95 list, 8½x11, 128p, order no. 1689.

AMHERST MEDIA'S CUSTOMER REGISTRATION FORM

Please fill out this sheet and send or fax to receive free information about future publications from Amherst Media.

CUSTOMER INFORMATION

DATE

NAME

STREET OR BOX #

CITY STATE

ZIP CODE

PHONE ()

OPTIONAL INFORMATION

I BOUGHT *SECRETS OF SUCCESSFUL AERIAL PHOTOGRAPHY* **BECAUSE**

I FOUND THESE CHAPTERS TO BE MOST USEFUL

I PURCHASED THE BOOK FROM

CITY STATE

I WOULD LIKE TO SEE MORE BOOKS ABOUT

I PURCHASE BOOKS PER YEAR

ADDITIONAL COMMENTS

FAX to: 1-800-622-3298